AMONG THE INUIT ᐃᓄᐃᑦ ᐊᑯᓂᖕᒋᓂ

Robert Semeniuk

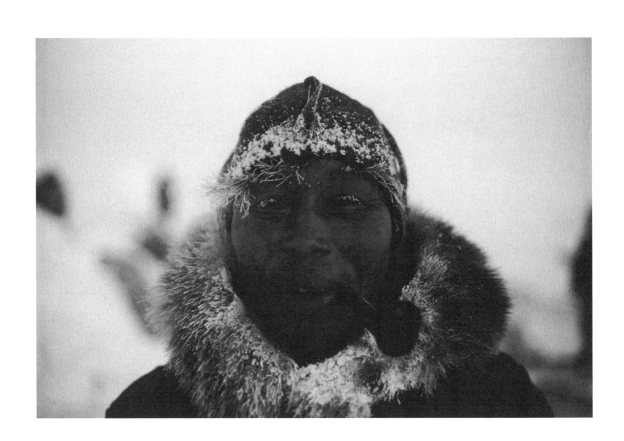

AMONG THE INUIT ᐃᓄᐃᑦ ᐊᑯᓂᕐᒥᓂ

Robert Semeniuk

RAINCOAST BOOKS

Vancouver

In memory of my father Con and my brother Don,

who were hunters, and of my sister Connie, who was a healer.

To the children of Igloolik, and to following your heart.

CONTENTS ᐃᑐᓕᖅᑎᑦ

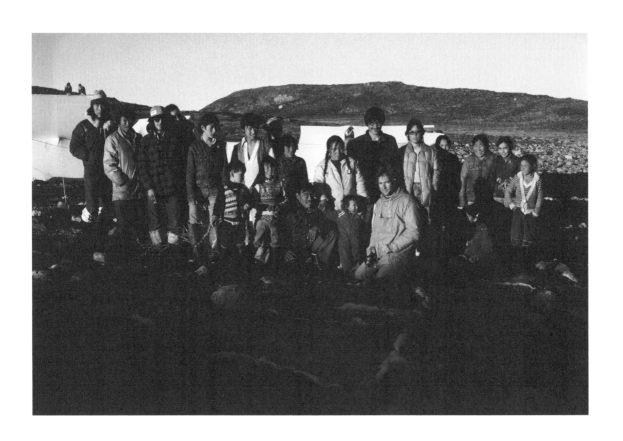

ACKNOWLEDGEMENTS ᐃᓕᓴᕆᔭᐅᔪᑦ ᐃᑲᔪᕐᓂ� ᓄᑦ

There are too many people to thank, over too many years. I will always regret the ones I forgot. My deepest thanks to the people of Igloolik who invited me into their homes and hearts and who shared their food and sleeping bags with me. You gave me a gift that will forever fuel my soul. To Paulosie Attagutalukutuk and all his family, especially Andy and Rebecca, who looked after me on the land as if I had been family. To my old and dear friend Rebecca Awa, and her family past and present, my thanks for the memories, for interpreting for me over all these years, and for the Inuktitut translations and the many contributions to the Field Notes appearing in this book. To my friends Hugh Brody, Wade Davis and Peter Irniq for their caring and enlightened contributions. To editor Scott Steedman, and Raincoast's Cindy Connor, Allan MacDougall, and Naomi Wittes Reichstein, who made the book happen. To Marius Tungilik and Rhoda Innuksuk for translating Peter Irniq's Statement. To Graham Rowley, who introduced me to Igloolik. To Andy Rhodes and John McDonald of the Igloolik Lab. To Bob Gilka, former director of photography at *National Geographic Magazine*. To the editors of *Canadian Geographic Magazine* and *Natural History Magazine*. To Nunavut Tourism. To Peter Williamson, Maureen Orban, Gary Fiegehen, Ulli Steltzer, Susan Parker, Sara Whitney, Dave O'Malley, Andrew Feldmar and Stan Gadziola for always having good ideas. To Jane Whitney and Steve Smith for the kayak trips. To my eternally supportive wife Ruta Yawney, my daughter Raya for her refreshing perspective, and my mother Vera for the years of inspiration.

Peter Irniq
Inuit Cultural Consultant
Former Commissioner of Nunavut

Robert Semeniuk's stunning photographs bring back many memories and stories for me, as a young Inuk raised on the land. They make me hear drum dancing.

Many years ago, my father, a great storyteller, told us that when it was a good year no one went hungry. Inuit would build a big igloo called a *qalgiq-qaggiq* and celebrate the passing of winter through drum dancing, throat-singing, wrestling, *ujauttarniq* (rope gymnastics) and other festive games. But it was *huqulaniq* (drum dancing, also known as *mumirniq*) that dominated our activities.

Drum dancing was sacred and spiritual. It was also a form of merriment and entertainment. When there was enough light from the *qulliq* (seal-fat lamp), drum dancing provided an opportunity for men and women to show off their best rhythms.

Women usually sang the songs. Songs of men of long ago. Being extremely good singers, the women would sing either alone or with several other women, to accompany and challenge the drummers. I can and do sing myself, as do other men, but I prefer the accompaniment of women. I never tire of their singing.

My first memory of a drum dance was at Christmas 1952. My father and mother preferred to live in Nattiligaarjuk or Tubliniq (Committee Bay) to be on the land, close to the caribou and the good fishing of those days. I can still see my father drum dancing. He danced with great joy to my mother's singing, chanting loud cries and reaching innermost insights and outer spirits — making a connection to the past and the land. The land is about stories. *Inuit* simply means "the people," those who live here. We are the place. My mother sang my father's hunting song. It was always the wife who sang her husband's song when he drummed. That was the custom.

Inuit celebrate achievement and accomplishments and socialize with one another by drum dancing. Through Inuit Qaujimajatuqangit (Inuit traditional knowledge), I sometimes hear the souls of my ancestors singing their songs. In the 1950s and 1960s, Roman Catholic missionaries, and likely some Anglican ministers too, tried to stop the ancient Inuit practice of drum dancing because they believed it to be connected to shamanism and Satanism. So it was in Naujaat (Repulse Bay) when I was growing up. For many years, Inuit were not allowed to celebrate their achievements or practise their spirituality. What a joy it is to drum and dance again.

ᐸᑕ ᐃᔅᓂᖅ
ᐱᖅᑯᔾᓴᓂᕐᒡᒪᑦ ᐱᓕᕆᔪ
ᑲᒥᓴᐅᓚᐅᖅᑐᖅ ᓄᓇᕗᒥ

ᕿᐳᑦ ᓯᒐᓄᐳᖯ ᐊᔾᓚᐅᖯᖅᑦᖯᕙᓛᓇᕐᒣ ᑕᐃᒪᓯᒥᖯ ᐃᖅᐃᔾᔪᑎᕐᓯᐅᕙᖯ ᓄᑕᖯᐅᔾᓛᒡ
ᓄᓇᒥ ᐱᕐᖯᖯᓚᒡ ᑐᖯᓯᓛᓚᓯ ᕿᓯᐅᒥᖯ.

ᑕᐃᓯᒪᓄᖯᓯᐳᑕᑳᑑᖅ ᐊᐃᑲᒪ ᐅᓇᖯᑲᒪᓇᑐᔾᑕᐳᖯᒪᕐ ᐅᖯᖯᐳᕒᖯᑲᐳᖯᒪᑐᔾᑕᐳ
ᐊᕿᔾᔪᖯᑎᖯᐊᔾᖯᒡᑦ ᖯᐳᖯᖯᐸᖯᖯᐳᕙᒡᓯᖯᖯ ᑕᔾᔾ ᐃᓄᐃᑦ ᐊᔾᒥᐊᔾᖯᒡᒥᖯ ᐃᐳᓯᖯᑦᖯᑎᖯᖯ
ᖯᖯᑦᕙᖯᐳᔾᑑᖯ ᖯᑐᐃᐊᔾᓐᖯᖯᓯᖯᖯ ᐅᕐᐳᖯ ᐊᓯᓯᖯᖯᓄᖯ. ᖯᕿᖯᐳᖯᖯᓯᒡᑎᖯᖯ ᖯᑕᖯᖯ
ᖯᓯᖯᖯ ᐱᖯᖯᔾᐊᖯᓯᖯᖯ ᐅᖯᐳᑦᑕᖯᓯᖯᖯ ᐊᔾᖯᕐᖯᖯᓯᖯ ᖯᑐᐃᐊᔾᔾᐊᔾᖯᖯ ᐱᖯᖯᔾᐊᖯᓯᖯᖯ
ᖯᐅᖯᖯᑕᓯᖯᖯᒡᒡ ᒡᕐᖯᓯᖯᖯ ᖯᕿᖯᐳᖯᖯᓯᖯᖯᒡ.

ᖯᕿᖯᐳᖯᖯᓯᖯᖯ ᐱᖯᖯᓇᐳᖯᐳᖯᓯᖯᑦ ᐊᖯᒡ ᖯᑐᐃᐊᔾᔾᐊᔾᐊᓯᖯᒡᑦ ᖯᕿᖯᐳᖯᖯ
ᖯᖯᖯᐳᓯᐳᖯᖯᒡᑎᖯᖯ, ᑕᐃᒪ ᖯᒡᖯᖯᐳᖯ ᐃᖯᑐᖯᖯᓯᓄᖯ ᖯᖯᐳᓯᖯᖯᔾ ᐊᖯᐳᐃᖯᖯ ᐊᖯᐃᐊᔾᖯ
ᐊᐳᖯᖯᔾᔾᖯᒡᖯ ᑦᑎᖯᖯᐳᐃᐊᐳᖯᓯᖯᖯᖯ.

ᐊᖯᐃᐊᔾ ᐃᖯᖯᖯᖯᓯᐳᖯᖯᓯᖯᖯᒡᑎᖯᖯ, ᐊᖯᔾᐳᖯᖯ ᐃᖯᖯᖯᔾᐳᖯᖯᖯᓯᖯᖯᒡᑎᖯᖯ ᐃᖯᒡᖯᖯᓯᖯᐳᖯ. ᐊᖯᐃᐊᔾ
ᐃᖯᖯᖯᖯᖯᐳᖯᖯᖯᒡᑦ ᐊᖯᒡᖯᖯᐳᖯᖯᖯ ᐃᖯᖯᖯᖯᐳᖯᐊᖯᖯᓯᖯᐳ ᐊᖯᒡᖯᖯᓯᖯᐳ ᐃᖯᖯᖯᖯᖯᖯᐳᖯᖯᐊᖯᖯᓯᖯᖯᖯ
ᑕᖯᐊᖯ ᖯᕿᖯᐳᖯᖯᔾᐳᑎ ᐃᖯᖯᐳᖯᖯᖯᓯᖯᖯᒡ. ᐱᐳᖯᖯᖯᓇᖯᐳᖯᖯᒡᑎᖯᖯᒡᑑᖯᖯ ᐊᖯᖯᑕᑕᖯᖯ ᐊᖯᐃᐊᔾ ᐃᖯᖯᖯᖯᖯᖯ-
ᓐᖯᖯᓯᖯ ᐊᖯᐊᖯᐊᐃᐊᖯᖯᖯᐳ. ᐊᖯᐃᐊᔾᖯᖯ ᐃᖯᖯᖯᖯᖯᐳᖯᖯᖯᖯᖯᖯᐳ ᑐᖯᖯᖯᖯᔾᐳᖯᖯᓯᖯᐳ.

ᖯᕿᖯᐳᖯᖯᔾᑑᖯᖯᖯ ᓯᖯᒡᖯᐊᔾᖯᐳᖯᖯᐳᖯᔾᖯᔾᐳᖯᖯ ᖯᑐᐃᐊᔾᖯᖯᐊᐳᖯᑎᖯᖯᖯᒡᑎᖯᖯᖯᖯ 1952-ᒥᖯ; ᐊᖯᖯᖯᑕᑕᖯᖯᖯ
ᐊᖯᐊᖯᑕᑕᖯᖯ ᓇᖯᖯᑎᖯᖯᔾᔾᖯᖯᐳᖯᖯᐊᖯᐳᖯᖯᐳᖯᖯᖯᑎᖯᖯ ᐳᖯᖯᖯᓯᖯᖯᖯ ᑐᖯᓯᖯᖯᓯᖯ ᓄᖯᖯᖯᐳᖯᖯᐳᖯᖯ
ᑐᖯᑐᖯᖯᖯᖯᒡᖯᖯᓯᖯᖯ ᐃᖯᖯᓯᖯᖯᖯᑎᖯᖯᒡᓯᖯᖯᐳᖯ ᓯᖯᐳᖯᖯ ᐊᖯᖯᑕᑕᖯᖯ ᑕᐳᖯᔾᖯᖯᔾᐊᖯᑎᖯᖯᐊᖯᖯᖯᖯ
ᖯᕿᖯᐳᖯᖯᔾᓯᖯᑎᖯᖯᐳᖯ. ᐊᖯᐊᖯᓇᖯ ᐃᖯᖯᖯᖯᖯᖯᖯᖯᖯᐳᖯ ᐊᖯᐃᐊᐊᖯᔾᖯᖯᖯᖯᖯᓄᖯᐳᖯ ᓯᖯᖯᖯᖯᖯᖯᐳ
ᐱᖯᖯᖯᑐᖯᖯᐳ ᑐᖯᖯᖯᖯᒡᖯᖯᖯ ᐃᖯᖯᐊᖯ ᐃᖯᖯᖯᖯᖯᖯᐊᖯᖯᓯᖯᖯᐳ ᐃᖯᖯᒡᒡᖯᖯ ᓯᖯᖯᐳᖯᖯᐳᖯ ᑦᖯᖯᖯᖯᓯᖯ
ᓐᖯᖯᐳ ᖯᓇᖯᖯᖯᑎᖯᖯ ᓄᖯᖯᖯᒥ, ᓄᖯ ᐅᖯᖯᖯᖯᖯᐊᐳᖯᖯᖯᖯ ᐃᖯᖯᐃᐊᔾᖯᖯ ᓄᖯᖯᖯᐳᑦ ᑦᖯᖯᔾ
ᓄᖯᖯᖯᖯᖯᑎᖯᐳᖯᐳᐳᑦ ᐊᖯᐊᖯᓇᖯ ᐃᖯᖯᖯᖯᖯᖯᓯᐳᖯᖯ ᐊᖯᖯᑕᑕ ᐊᖯᖯᔾᐊᖯᐳᔾᖯᖯᐊᖯᖯᓯᐳᖯᖯ ᐊᖯᔾᐳᖯ ᖯᕿᖯᐳᖯᖯᔾᖯᖯ
ᓇᖯᐊᔾᐳᑦ ᑕᐃᒪᖯᖯᓇᖯᓯᐳᖯᖯ ᓄᖯᖯᐊᔾᐳᖯ ᐃᖯᖯᖯᖯᖯᖯᐳᖯᖯᐊᖯᖯᖯᐳᑦ ᐱᖯᖯᑯᖯᖯᑐᖯᖯᐳᑦᖯᖯᖯᐳᖯᖯᐳ. ᐃᖯᖯᐃᐊᖯᑦ
ᖯᑐᐃᐊᔾᐊᖯᖯᖯᓐᖯᐳᖯᒡᖯᐊᓯᖯᐳᖯ ᐱᐊᔾᖯᖯᔾᖯᐊᖯᖯᑐᖯᖯᖯᖯᔾᐊᖯᖯᓯᖯᖯᐳᑦ ᖯᑐᐃᐊᔾᔾᐊᖯᓐᖯᖯᖯᔾᖯᖯᖯᓯᖯᖯᑎᖯᐳᖯᔾ ᐃᖯᖯᐃᐊᖯᑦ
ᖯᓇᖯᖯᖯᖯ ᑕᐃᒪᖯᓇ ᐃᖯᖯᖯᖯᖯᖯᖯᑐᖯᖯᔾᐳ ᖯᕿᖯᐳᖯᖯᔾᐳᔾᐳᖯᔾᑎᖯᖯᖯᐳᔾ. ᐃᖯᖯᐃᐊᖯᑦ ᖯᖯᐳᖯᖯᖯᔾᐳᖯᔾᖯᖯᖯᖯᐳᑦ
ᑕᐃᖯᖯᑦ ᑐᖯᖯᖯᐳᖯᖯᖯᐳᑲᖯᖯᓛ ᓯᔾᖯᑕᖯᓯᖯᖯᖯᔾ ᑦᖯᖯᖯᖯᖯᐳᑦ ᐃᖯᖯᖯᖯᖯᖯᖯᑎᖯᐳᖯᔾᖯ. ᑕᐃᖯᔾᖯᓛᓇᖯᖯ
1950-ᒥᖯᑦ 1960-ᒥᖯ ᐃᖯᐃᐳᖯᖯᔾᔾᐊᖯᑦᖯ ᐊᔾᐊᖯᔾᐃᐊᖯᖯᐳᖯᖯᒡ ᑕᐳᖯᑐᖯᖯᖯᐳ ᐃᖯᖯᐃᐊᖯᑦ ᐱᖯᖯᑯᔾᖯᖯᐳᖯᖯᖯᒥᖯᖯ
ᓄᖯᖯᖯᖯᖯᖯᑎᖯᖯᓇᔾᔾᐳᖯᖯᑦᖯᖯᐳᔾᖯᖯᔾᐳᖯ ᐊᔾᖯᓯᑐᖯᖯᖯᐳᖯᖯᖯ ᑕᖯᖯᖯᓇ ᐊᖯᑐᖯᐊᖯᖯᖯᖯᖯᖯᕐᖯᖯᑐᖯᖯᔾᐳᖯᖯᖯᖯ
ᐱᐳᖯᖯᖯᑐᖯᖯᖯᖯᖯᖯᖯ ᓯᔾᐊᖯᔾᖯᖯᐳᖯᖯ ᐊᖯᖯᐳᔾᐊᖯᓇᖯᖯᖯᖯᐳ ᓄᖯᐳᖯᖯ ᑕᐃᒪᐃᐊᖯᖯᐳᖯᖯᖯᐳᖯᒡᖯᖯᐳ. ᐃᖯᖯᐃᐊᖯᑦ
ᐱᐳᖯᑕᐃᓐᑕᐳᖯᐳᖯᖯᒡᑎᖯᖯᐳᔾᖯᖯᖯ ᐱᖯᖯᑯᔾᐳᖯᖯᖯᖯ ᖯᖯᖯᖯᓯᖯᖯ ᖯᕿᖯᐳᖯᖯᔾᓯᖯᖯᖯᔾᐳᖯ ᐊᖯᑐᖯᖯᖯᖯᖯᖯᓇᔾᖯᔾᐊᖯᑦᖯᖯᖯᔾᖯᖯᔾᖯᖯ.

FOREWORD ᐱᒋᐊᕐᓂᖓ

Hugh Brody

Time stands still in photographs. This is a cliché of photography. And time never stands still. Which is a cliché of life itself. This book speaks to the paradox of these opposing truths.

Most of the images here come from one crucial period in Robert Semeniuk's life: from his time in Igloolik, an Inuit community in the furthest northwest corner of Hudson Bay, deep in the High Arctic. The passion and engagement that inform the images are rooted in the many trips Robert made to the North between 1968 and 2000. But this is a book about one place at one particular time and centres on a small number of Inuit with whom the photographer spent immense amounts of time in the closest of circumstances. The first of the photographs here was taken in 1976 and the last in 2000. Robert says of his experience of Igloolik: "I realized I was only ever alone when I closed my eyes."

Almost all the images in this book are, therefore, of people: hunters on the ice, at the floe edge, on the tundra, throwing a harpoon at a snow goose or a bearded seal; men and women doing things — completing a snow house, turning Arctic char into *pisik* (the Inuit equivalent of smoked salmon), cleaning a caribou skin — and groups of young people at a dance, in a church service, on their bicycles. People in action. So we look at the photographs and sometimes wonder what happened next: did the hunter get the goose or the seal? Was the *pisik* eaten right away, or after how long on a drying rack? Did the children in the church attend communion, and did the kids at the dance go on long into the night?

We do not always wonder about the stories into which the photographs fit. Some are of vast landscapes and defy the mundane questions, the concern with narrative. In this way they are timeless. And there are some who would cavil at my engagement with the unspoken, concealed narrative, arguing that all great photography (and this book does indeed show us great work) stands both in and outside time, capturing moments but telling us something more, something that is not dependent on what came before or after the moment. I *can* look at these photographs, including those that are of vast or astounding landscapes, and find their timelessness — their beauty and resonances. But I am reluctant to do so. My reasons for this reluctance are

at the heart of what I want to say in this introduction to Robert Semeniuk's Arctic work.

The year 1976 — the date of the earliest image in this book — is not long ago. The direct ancestors of modern Inuit have been in Arctic Canada for at least five hundred years. Ancient house sites that have all but disappeared into the tundra, and strange, exquisite miniature carvings found deep in the permafrost, show that the Inuit were preceded by other Arctic peoples. Archaeologists have found evidence of continuous occupation of Igloolik Island stretching back some four thousand years. There are photographs here that evoke some of these spans of time: a rock (or is it the ancient skull of a bowhead whale?) bright with lichen on a pebbled beach, with two tiny figures visible against the shore ice in the far distance; a figure paddling a tiny craft in a huge, still and misty sea; a child standing at the narrow entrance of a tent; a woman adjusting the wick of her *kudlik*, the stone lamp that Inuit no doubt used for heat and cooking in their snow houses when they first came into the lands that are now their own. In a way, these are images that could belong in the Arctic at any time since Inuit first came there.

Those of us who were lucky enough to be in the Canadian North in the 1960s and '70s were able to spend time with Inuit on the land in settings, with technologies, and in families that could allow us to think we had stepped outside our own kind of history and into a flow of social life that seemed to take us far back in time. In those days, many Inuit travelled with dog teams, wore caribou-skin clothing from head to toe, hunted seals with harpoons, speared fish with a leister and ate all the "real" foods: raw, frozen, wind-dried, seared on open fires. It was still possible to take photographs of Inuit life that made it look as if it were beyond the changes that fur traders, missionaries and the Royal Canadian Mounted Police had brought to every family. Images that seem to be "traditional."

Even in 1970, however, these appearances were deceptive. Hunters all used guns as well as harpoons; families travelled to and from their seasonal camps in boats built in the South, powered by engines; most cooking was done on stoves fuelled by naphtha. Beneath the caribou outer clothing, everyone wore shirts, socks, sweaters and parkas made of wool, cotton and

nylon. And diet depended on many items that came from the store, from sugar to pilot biscuits to tins of corned beef. Changes in items of material culture were matched by parallel changes in intellectual and spiritual life: when Robert Semeniuk was living and working in Igloolik, he spent his time with men and women who were devout Christians and whose children all went to school. The changes — complicated, at times confusing — had been taking place for at least a generation before Robert first went to the North, and they continued to take place, with increased complexity and an accelerating pace, thereafter.

So I look at the photographs here and wonder where they fit into this flow of changes, in defiance of the stillness of the images and alive, instead, to the way time never stands still. What do these photographs say about the meaning of the land to the Inuit and other hunting peoples — since we know that just about all Inuit now live in more or less permanent settlements? How do these images speak to the people who suffer many kinds of social and personal stress in their settlements — from family violence to youth suicide? I cannot look at these pictures and somehow erase from my mind a more disturbing set of stories about life for Inuit and for Igloolik. Nor can I allow the kind of amnesia, or nostalgia, or myth-making, that allow these photographs to stand as representative of an ideal moment in Inuit life and time. The men and women Robert Semeniuk met and spent time with in the 1970s must include some of the parents of the children who seem to be among the most disoriented and despairing of all people in Canada. Why else would they have suicide levels that are, in some cases, up to fifteen times the national rate?

This is an uncomfortable line of thought that may seem to disregard the photographs for themselves. After all, they are a powerful and beautiful celebration of Inuit life, Inuit land, and the Igloolik of thirty years ago. Am I pushing questions about these images in defiance of the sense and purpose of a wonderful photographer? Are these preoccupations that need not or should not bear on this work? I think not. Robert Semeniuk asks these kinds of questions himself, in the introduction and field notes that accompany these photographs, and in letters he has written to me. When first

telling me about this collection of images, he wrote to me, saying, "The only way I would like these pictures to be published is if they are used as a tool of enlightenment rather than the entrancement which keeps us stuck in what I call a comfortable dis-ease." The "dis-ease" he speaks of is the web of discomforts, inner disorders, and sicknesses of the soul that come with ignorance of, indifference to, and any final separation from the life the pictures evoke. Yet knowing what he knows about the history — the stories, the changing times — of the Inuit, Robert also resists any insistence that here is the idyll we all need. The photographs are discomfiting to the photographer himself. He also knows that the Inuit world in general, and Igloolik in particular, have shown since the time when most of them were taken that these kinds of pictures are not what they seem.

Later in the same letter, Robert also wrote: "These pictures are more than they appear to be. They are really only dreams of the way things were. My dreams, images, of touching the earth with people who know how to do this. And feeling what this is like, a little … Feelings I don't often have but that my soul yearns for."

In these sentences, I hear the voice of a man who grasps at the extraordinary power of the land as it is made into a way of life by those who know it best, and for whom it is most deeply home. The voice of a man who has found surprising kinds of comfort as well as more obvious delight in the land, in the meaning of the land; and who found, again and again, on returning to the cities of the South after living in the North, that his soul felt constricted, his self diminished, by the shock of the loss of the Arctic, his sudden distance from that life. Here is a man, therefore, who also knows that he is grasping, as we all must, at any chance to find meaning in life despite the lack of meaning we experience so much, so often. Robert Semeniuk is expressing his own alienation; but when he says that he is dreaming, not establishing the real, he acknowledges that the Inuit are not simply what these images might seem to say they are.

This is complicated, and in some ways involves a tension between two views, both of which I suspect are part of Robert's thinking. The Inuit relationship with their lands — the core of their heritage and culture — is

a source of profound strength. This is what the Inuit were telling Robert at the time, and this is what all indigenous people mean when they speak of the power of their culture. On the other hand, by the 1970s, the affirmation of this culture was already touched with anxiety and even despair. Newcomers had taken over, as putative owners and managers of it all, as "superior" in power and wealth, and as purveyors of things, beliefs and ways of life that were not to be resisted. Already the settlement — the trading post, the church, the police — had the Inuit in its grip, at least for part of the year, to meet a set of new and important needs. Already Inuit elders looked at their young and saw that they were becoming strangers to them, and the young often felt that they had become remote from much that their elders were so sure gave life its value and meaning.

Of his time with the Inuit in the 1970s, Robert wrote: "I frankly couldn't stand being in the village for more than a few days at a time. It represented too much of what I despise in life. All the things that make me cynical." Yet these things already comprised a large proportion of Inuit life — the village was where the people had permanent homes, where they stayed most nights of the year, and where their children went to school. And these things were chosen as well as imposed. The life on the land, full of power and fascination, the source of strength and meaning, was already, for the Inuit, giving way to life in government-created settlements. This explains the poignancy of these photographs — shaping the dream they seem to be.

When writing to me about the dream, and about the way the Inuit were caught in the web of needs created and met by the South, with its settled and scrappy kind of modernity, Robert revealed the anguished, personal connection he has with events in the North. This is difficult for him to speak of, yet has a powerful place in these photographs. He wrote about the alienation he saw and sensed, and about the death of his brother: "I think this is one of the reasons the world is so fucked up. Because we are going against the grain. It is the reason my brother committed suicide. All he could say at the end was 'I've really blown it, I've really blown it,' and when I asked him what he had blown, he replied: 'Everything.' My brother wanted to be a wilderness guide; instead he ran a jewellery business."

This intensely personal link with his journey into the Arctic, between the self and the experience of the North, is integral to how Robert Semeniuk sees these photographs. Their meaning for him is bound up with the disaster that overwhelms people, young men in particular, who are not able to be what they need to be. Over the last couple of decades, the high levels of suicide in the Canadian Arctic, concentrated in young Inuit men, have raised questions about meaning — of life, and of the land as sustainer of life. Inuit elders say, again and again, that the land offers the basis for health for their young people. They are sure that the purpose and value of life can be found there, and that if they can have the chance to teach the young about Inuit heritage and values, then the young will have both reasons and the will to live. And there are many who also say that if the young were to spend time on the land, they would find strengths and confidence and joys, as well as a sense of themselves, that would ensure they did not collapse into complete despair when the upsets of every life — a broken love affair, a failure to find enough to do, a feeling that there is no future — erupt with their awful predictability in settlements where boredom and underemployment are the norm.

The photographs in this book may therefore be the appropriate and necessary dream. Robert Semeniuk is clear and open about the way that his time on the land with Inuit families transformed him. As he also says in his letters to me: "For me these pictures are graphic reminders of connections that I believe are imperative to having a more enlightened world." They also remind him of a place, a people and a time in his own life, when "blood meant life not death, and living the questions made more sense than seeking answers."

So we can look at these images and see a dream — of what was or might have been, and, more importantly, of what we might need to see. The Arctic is, in the true sense of the term, a fantastic place — somehow beyond the real, exciting in us a great sense of wonder and somehow existing more in the imagination than in the reality of some actual North. It is made thus as much by the wonderful skills, personality and technology of the Inuit when they are on their lands as by the lands themselves. These are what

you see in the photographs, of course, and so the photographs invite us to take imaginative leaps, and — in the light of all that we know has happened in the North — to interrogate these images. And after asking the questions I have posed here, one is left with a sense at least of possibility. Perhaps the North, or at least the Arctic of the people of Igloolik at the time when Robert Semeniuk was there, does show that the despair of the present, the despair of so many young people, can be answered. Not by a return to some traditional time that, no doubt, never quite existed, or to a timeless reality that has never been real or timeless, or to a mythic kind of in-the-moment happiness. If this life of an ideal past ever was lived in the moment, it was abandoned as soon as those who are supposed to have delighted in it had the chance to find other, more reliable — and less in-the-moment — forms of economic security.

Critics of land claims and sceptics about all forms of cultural revival argue that endeavours that look to a "tradition" that never was, or to a timelessness that is neither real nor possible, do not make real sense. They say that here is another kind of myth — about both the past and remedies. And they insist that those who urge such projects — be they Inuit elders, political leaders or troubled scholars and photographers — can only expect to be disregarded by the young men and women they want to win to a particular view of Inuit heritage or a restrictive kind of life on the land. There is force to this view, of course. Mythic representation of the past and unreal views about the future do indeed create risks.

But we must be wary of yielding too much ground to such opponents of land claims and related attempts by some of the most vulnerable peoples on earth to recover pride and strength for themselves as individuals and for their societies as a whole. The way that people who have grown up on, or dependent upon, the land around them feel about that land is an intense reality. The kinds of satisfaction, sense of purpose and inner energy that come to those who "go back" to their lands, and to the heritage in which understanding of the land is inscribed, are also very real. And the rediscovery of knowledge about lands and heritage can be a powerful and valuable resource, with value that is both intrinsic (for it has to do with sense of self

and place in the world) and extrinsic (for it can have to do with building economic and social opportunities that make all kinds of sense).

This is not to deny that the settlements, and all the kinds of modernity within which Inuit and many other indigenous peoples make their present, modern lives, are real. It is just that there are two kinds of reality, and many mixed realities that lie between them, or complicate them. There is no such thing as a pure aboriginal tradition to which anyone can, or would much wish to, return. Nor is there a modern reality in which heritage has no place and indigenous culture no efficacy. When Inuit speak of the power and meaning of the land or "culture," they are not slipping into some form of romantic self-deception, and those who insist that these are just myths do the Inuit and their rights a great injustice. On the other hand, those who urge that the reality of the land and heritage are the sum of the truth, and the only guides to what is wrong in the present or going to succeed in the future, are also failing to speak to what is real in ways that are realistic. Overstatement of modernity is as much a misconception as parallel exaggeration of the vitality or extent of "tradition."

Robert Semeniuk is adamant that he does not want these photographs to play to either of these deceptive and unreal notions. Rather, the images here serve to remind us that there is a dream of the Arctic that must continue to enchant, and a sense of place — on a particular land, and on the land itself — for those who wish to explore it.

A journey into these photographs, like a journey with Inuit hunters onto the land, is a powerful but complicated experience, being something for itself but also for the narratives that are implied. Each trip is a story within which there are many stories; and each trip, even as much as thirty years ago, begins and ends with a settlement, a place where every part of modernity is to be found. How we think about this journey — leaving, and then returning to, the village, the house, the central heating, TV, the Web — is a part of being on the journey. We cannot leave what *is* — and for better or worse, the modern is what is. Yet we can often feel that we do need to leave it, for a while, in a way. So if we are lucky enough to be taken by Inuit onto the land, we do so carrying all of ourselves and our society

along with us — in our minds, with our thoughts, as questions that urge themselves on us. Even if we cannot go on such a journey in the real world, we can do so in these photographs — carrying the same questions, puzzling in the same way about what is real in the images, what stories they hold that are not told, what came before and what came after. In this way, as Robert Semeniuk says, the photographs here are not what they appear to be: they are a puzzle that needs to be answered, a set of stories that need to be told. This is their strength, and, from the photographer's point of view, the reason for publishing them now.

INTRODUCTION ᓇᓄᖃ ᐃᓯᐊᕆ

Robert Semeniuk

I cherish the summer of 1976, when I first camped with Paulosie Attagutalukutuk's family of nine in a canvas tent on Baffin Island. We ate raw seal liver on the sea ice and cracked open caribou legs to slurp out the marrow. I arrived a stranger and left with new tastes and a deep respect for my Inuit friends. It was a good day when other Inuit came to our camp and joked about me, the *qallunaaq*, the white man, and Paulosie told them that the *qallunaaq* had travelled with them for a long time, that he hunted and ate raw meat and was like a member of the family.

The lessons were endless. Being lost — not knowing how to get back to Igloolik, whether at sea or on land — was a common condition, for me at least. For Paulosie, however, everything was familiar. He was home. He belonged to the land more than the land belonged to him.

With a few exceptions, all the photographs in this book are about being on the land. This is what led me to Igloolik — to document people who live on the edge of habitability, in one of the most adaptable cultures on earth. I found a big difference between "settlement life" and "being on the land." I didn't much enjoy being in the settlement. It represented too much disharmony, dysfunction and dissatisfaction. People were different on the land, more heartfelt, more genuine, happier. Many, many things were different. Ami Panimera, an old friend, once told me, "We don't belong in houses." But the fact is, all Inuit now live in houses. One old fellow I know is considered kind of "crazy" in town, but when he is out on the land he is one of the best hunters around. He surprises even his relatives.

Caribou hunting involves driving around in boats or snowmobiles, stopping often, looking for signs, and walking up to high places the better to scan the tundra for movement. One time during the darkness of December, while hunting with Andy Attagutalukutuk, Paulosie's eldest son, we came upon the frozen entrails of three caribou. On closer inspection with my flashlight I could see how diligently the ravens had pecked away at the rock-hard piles. Andy told me that these caribou had been shot two weeks before. He named the hunters and told me who their relatives were. Earlier we had stopped where he said his father always found caribou. And before that was a place where a friend's grandparents had lived a long time

ago, and before that was the place where his cousin had shot a polar bear the previous year. Like his father's, Andy's Arctic is mnemonic and intertwined with history. Each place has a meaning that is inseparable from the stories and experiences attached to it. And when I asked Andy how he knew where he was going, he simply said, "I follow my instinct."

Late one summer, we were in Foxe Basin in Andy's motor boat when fog, ice and darkness came. After a few stops and manoeuvres to push ourselves between the huge ice floes, my curiosity about Andy's ability to navigate in fog, at night, with not even a wisp of wind to give him any hint of direction, gets the better of me.

"Where are we?" I ask. Andy slows the boat, and with a huge smile on his face, he says, "I don't have any idea where we are." We laugh. "Is it a joke?" I ask. "No," Andy says, "I really don't know where we are, and I'm laughing because you don't believe that we are lost. Do you know how to use a GPS?" he asks, pulling a Global Positioning System instrument out of an old sock from his food box. Andy informs me that he used his GPS only once, about a year ago, and that the batteries might be dead, and the instructions are at home. He then stretches out and is soon fast asleep. Waves lapping against ice break the dead calm of the icy night sea. Then I hear the awesome sound of a bowhead whale breathing, very near us. Andy snores. He destroyed his dog team three years ago because it was too much work to hunt seals to feed them when he would rather hunt caribou. He joked about how Rebecca, his wife, thought he was spending more time with his dogs than with her.

Going onto the land was a way to touch the earth with people who put profound meaning on this connection. Making the photographs was a good way to do this. Now, they are fleeting reminders and memories that bind the heart and land. Archetypal connections from a long way back that are more than they appear. They represent places where I don't live, but that my soul yearns for. Places where the dictates of the forbidding ecological niche that the Inuit ancestors occupied presented few options for survival. Where hunting successfully and living with the weather were the preoccupations of everyone. Where permanence and accumulation were not

practical or sustainable. Where clothing and shelter were temporary, things that came and went, like words and ice and tools, which belonged to whoever needed them. Places that required pragmatic skills like hunting and trading, where a willingness to share meat determined social status and success was measured by wisdom, not wealth. And where, after everything else has gone, the experience remains, and my life has been changed forever.

Camping for months at a time, I was only alone when my eyes were closed. In the privacy of my own thoughts, I could easily imagine Inuit living four thousand years ago, in frigid darkness, always vulnerable, close together inside a crowded igloo, tent or sod house, and how sharing everything led to deep respect for the sanctity of one's own thoughts. Thoughts were one of the few things considered to be personal property, easily violated by questions, disagreement or analysis. Typical *qallunaaq* questions about "when" and "how far" are irrelevant, and simply receive a shrug. One does what has to be done, no matter how long it takes. One morning in a summer camp, I felt compelled to apologize to Andy for not helping to slide the boat, using caribou heads for skids, into the water. Looking surprised, Andy replied, "It doesn't matter if you take pictures while we carry the boat. Everybody does what is necessary."

Paulosie often stopped his boat for reasons that escaped me. One night, while we were lying on our caribou-skin beds having a conversation, I asked Andy why we stopped in the boat so often, and he said he did not know the reason. "Why don't you ask your father then?" I asked boldly. "To ask why," Andy replied, "is a stupid question. He would think it's a stupid thing to say. I know he has a good reason for what he does, and if he wanted to tell me, he would."

In Inuktitut, one's thoughts are called *isuma* — a rare abstraction in a tangible world. Except for about sixty of the last four thousand years of Inuit habitation here, cooperation, sharing and a cunning alertness to the spatial qualities of their environment proved more useful than ownership, accumulation, competition and even the concept of time. Living on the edge of habitation, these were all foreign concepts to a culture oriented to the present and the concrete. Perhaps it should not be surprising that the

suicide rate among Inuit is, in some settlements, as high as fifteen times the Canadian average.

For me, these photographs are graphic reminders of connections that I believe are imperative to achieving a more sustainable and enlightened world. My biggest fear in publishing them is that they will be seen to perpetuate myths, to prolong romantic notions about the Inuit that serve only to numb us from the truth about them and ourselves. There is already far too much propaganda in the world, too many bad beliefs. My hope is that these photographs will be seen as tools of enlightenment rather than the entrancement that keeps us stuck in our modern but comfortable "dis-ease."

Whenever I look at the sea ice, I am surprised that anything, even polar bears, can survive out there. I think about time, distance and scale, and how a footstep doesn't take you very far there. When I feel the icy wind bite my face, I remember what Koonoo, Martha Naqitarvik's sister from Arctic Bay, told me one time between stories of shamans, cannibalism and connections with the land: "I think the world around us is hearing. That is why the wind has stopped ... And if we stop talking, the wind will come back."

ROBERT SEMENIUK

Igloolik, 1998
Vancouver, 2007

ᑕᐳᑦ ᓯᒥᓂᐅᒃ Robert Semeniuk

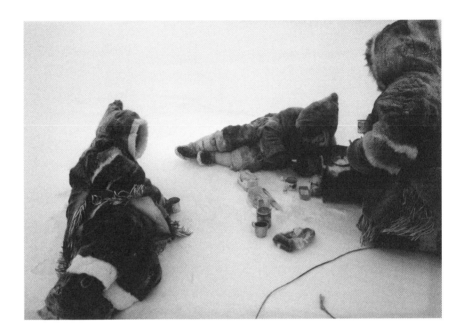

PLATES ᐊᔭᐳᖅᒧᐊᑦ

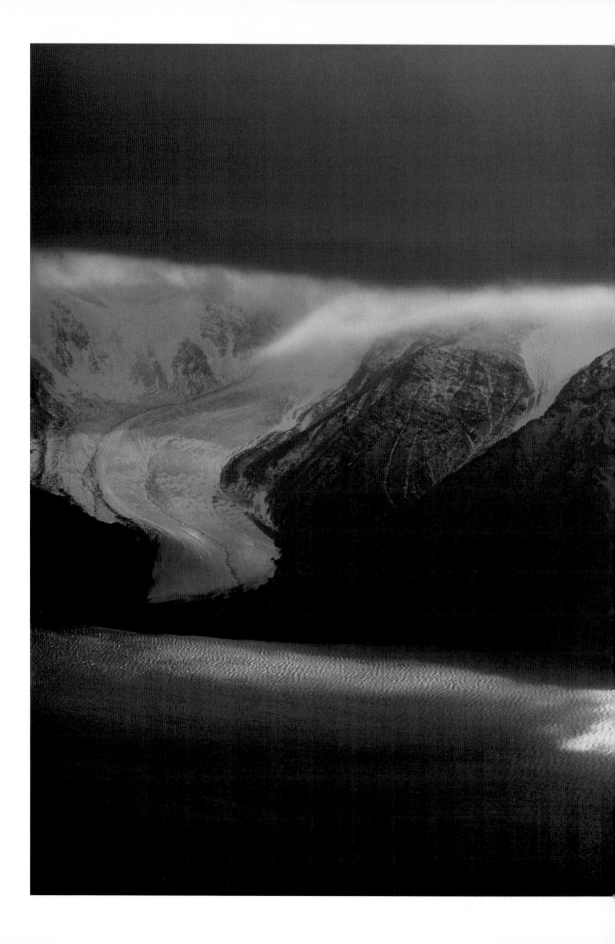

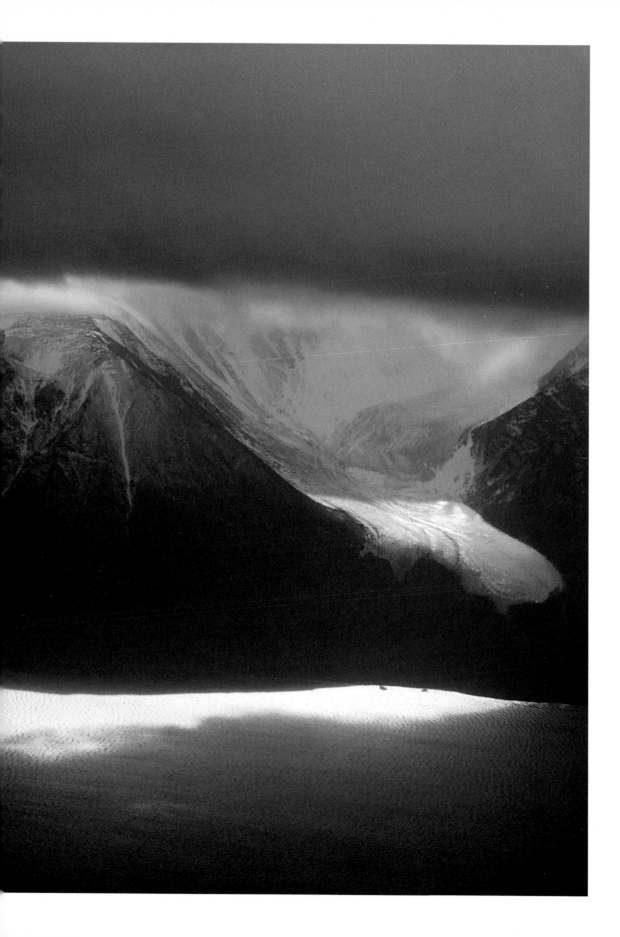

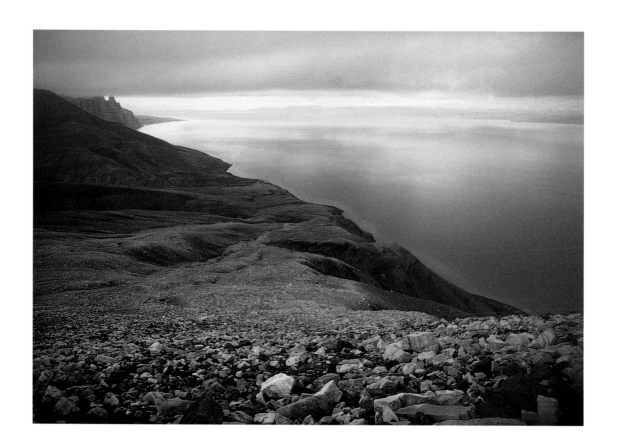

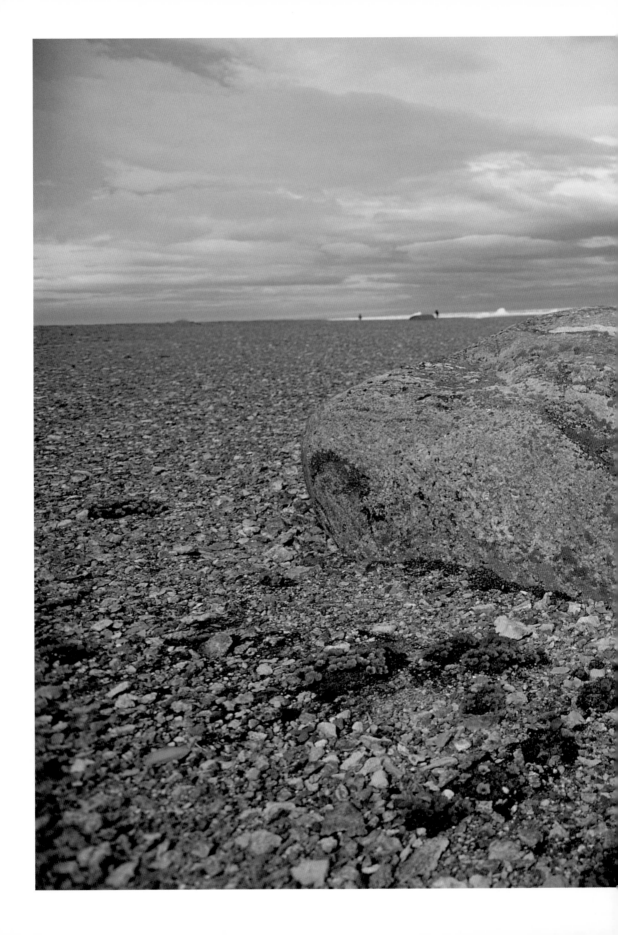

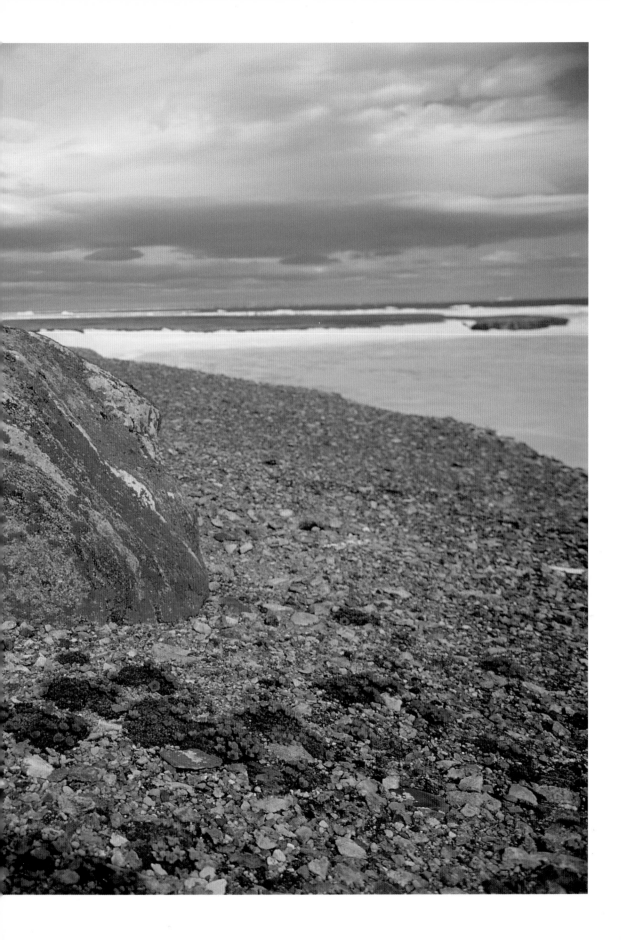

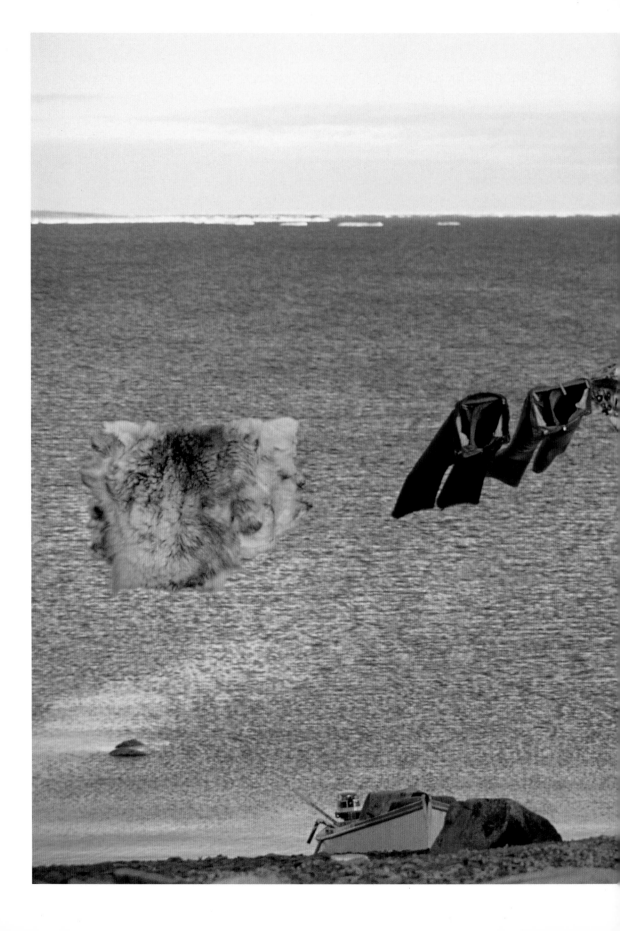

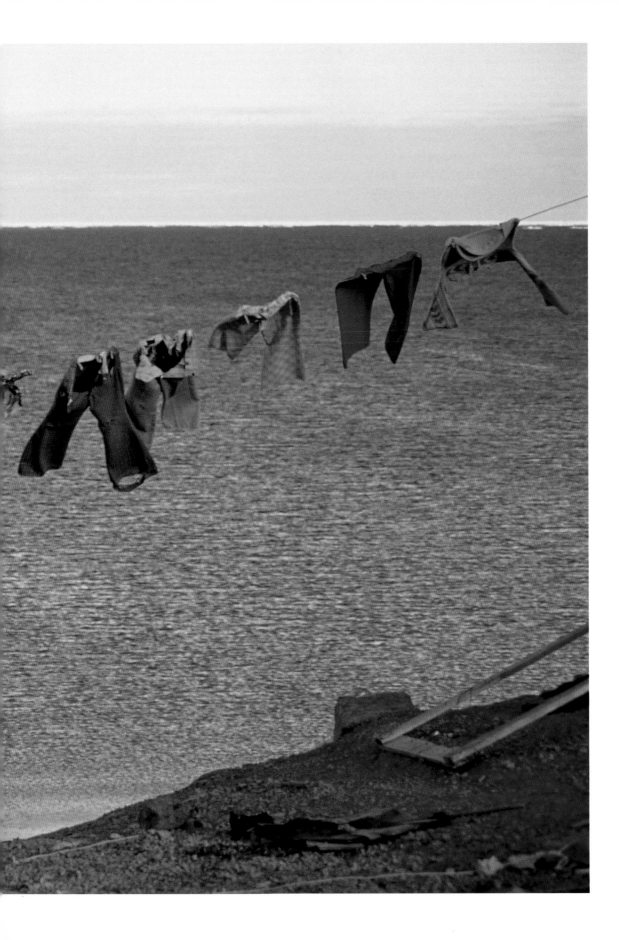

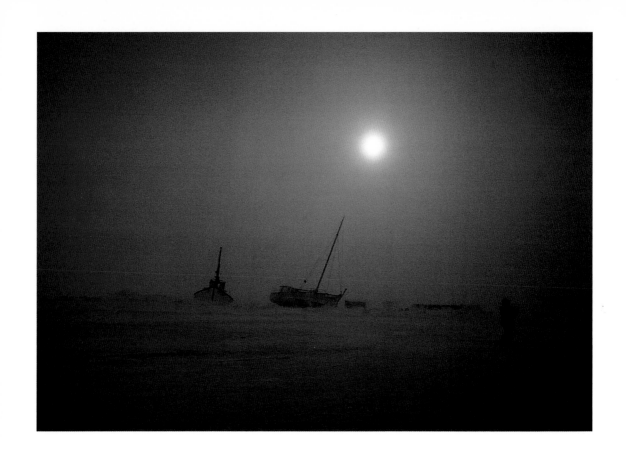

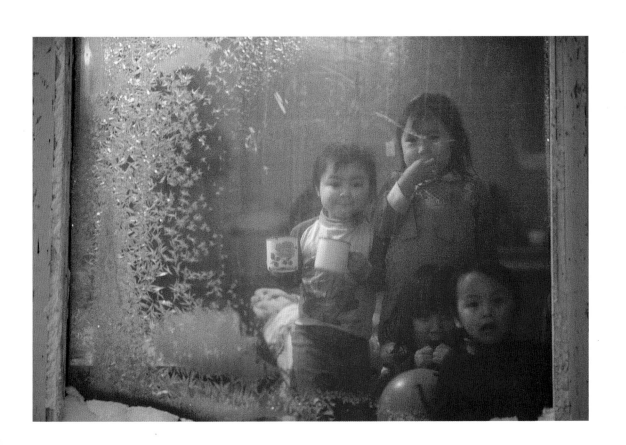

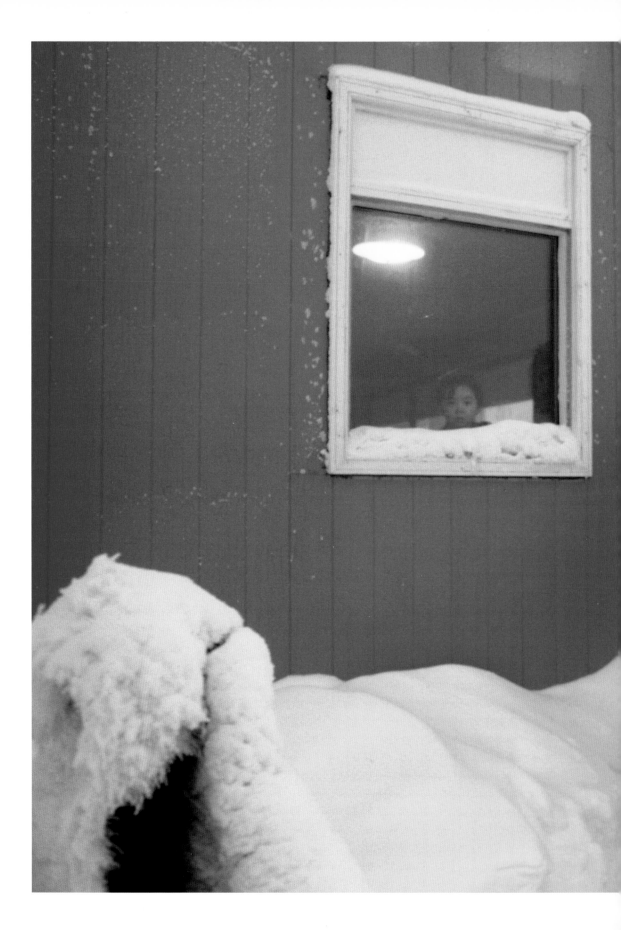

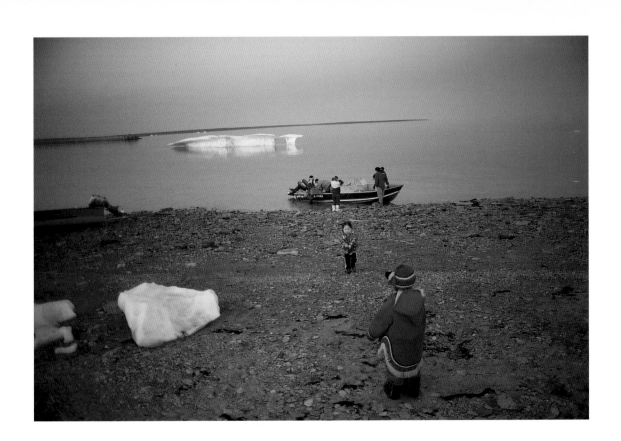

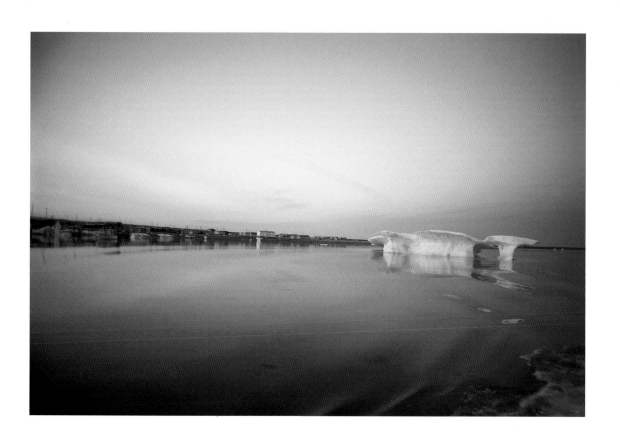

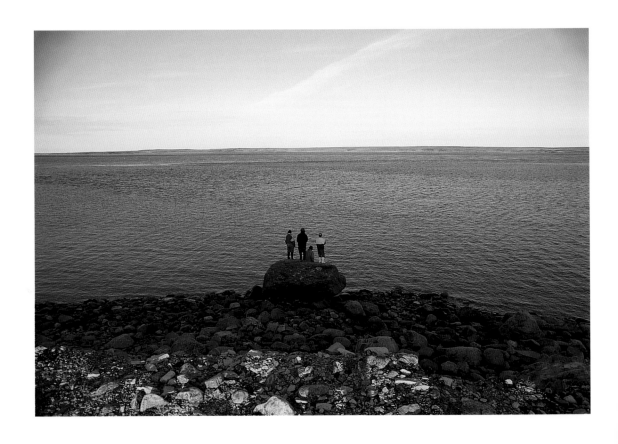

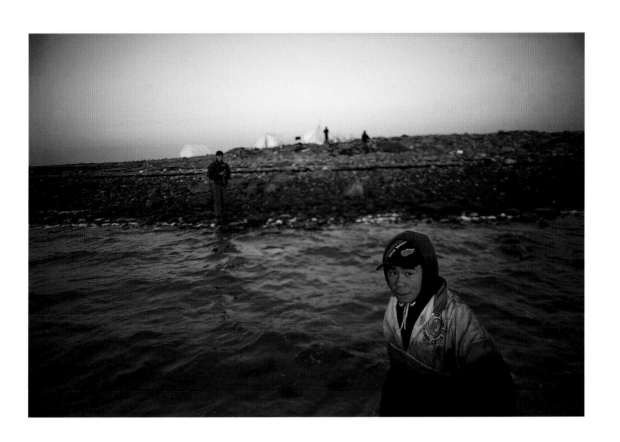

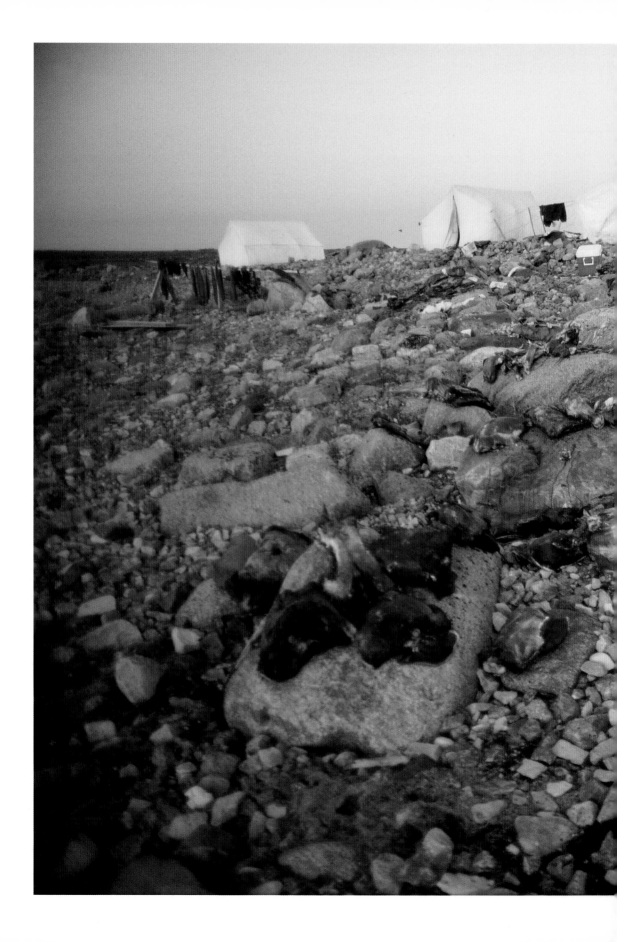

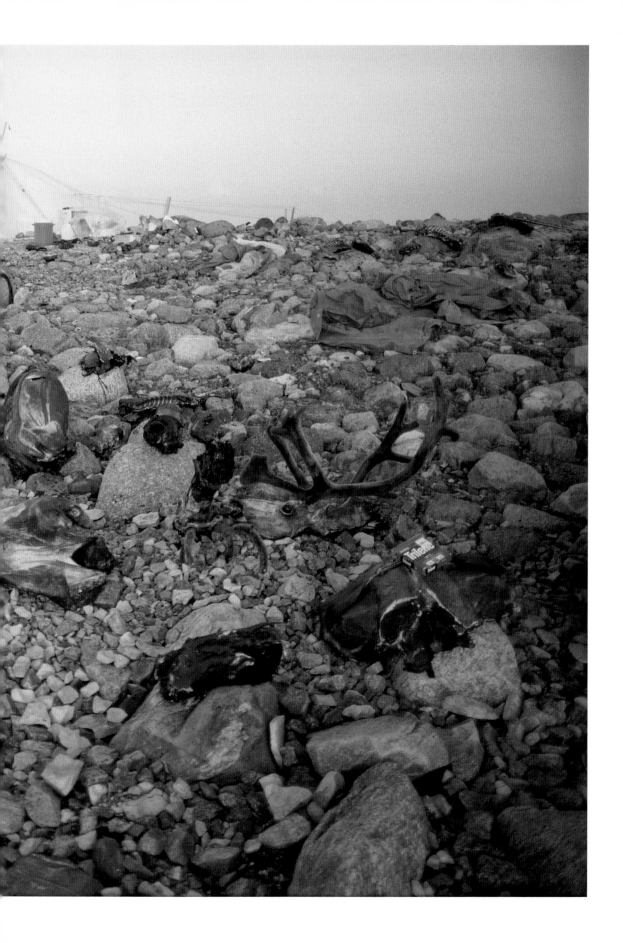

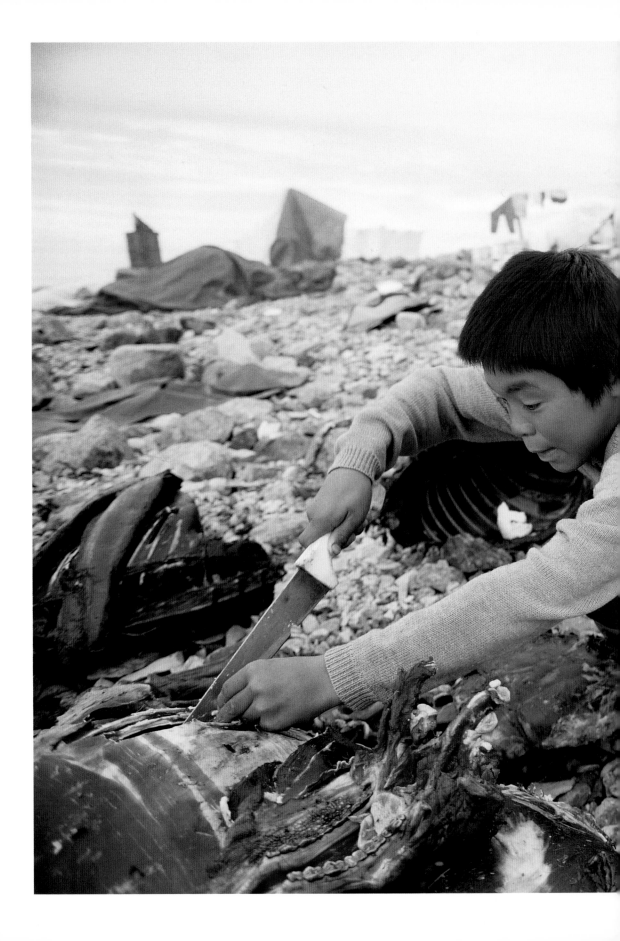

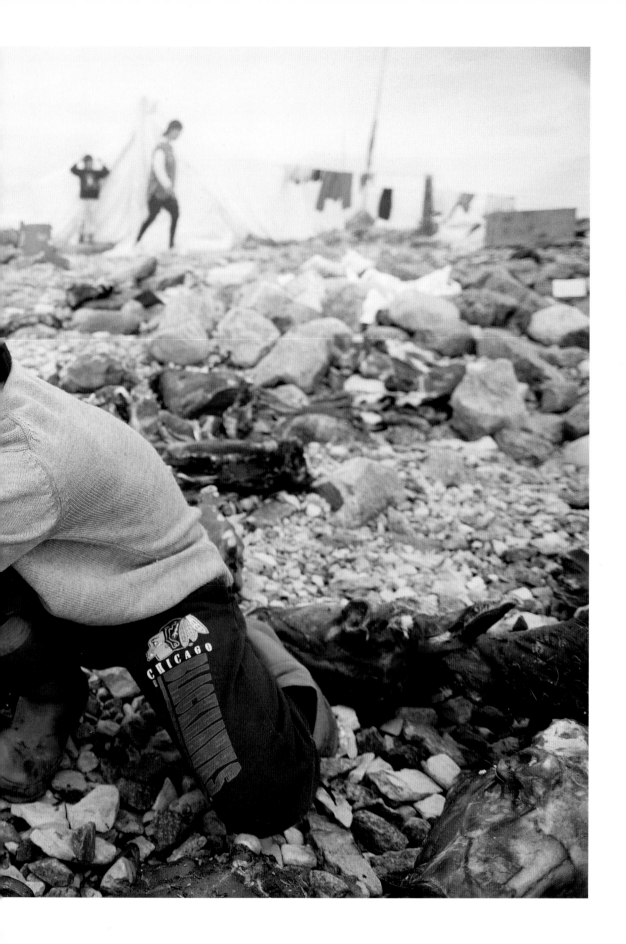

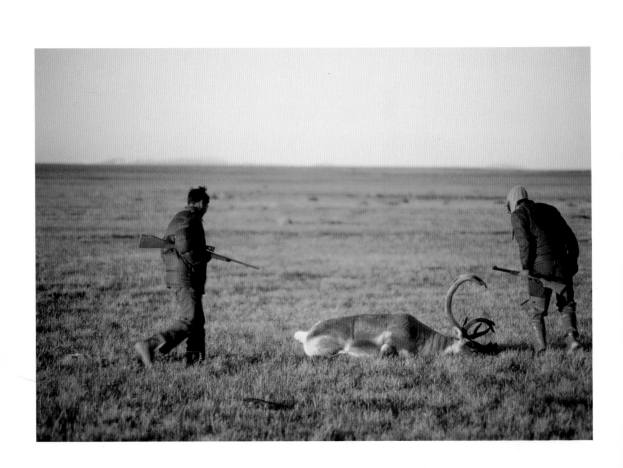

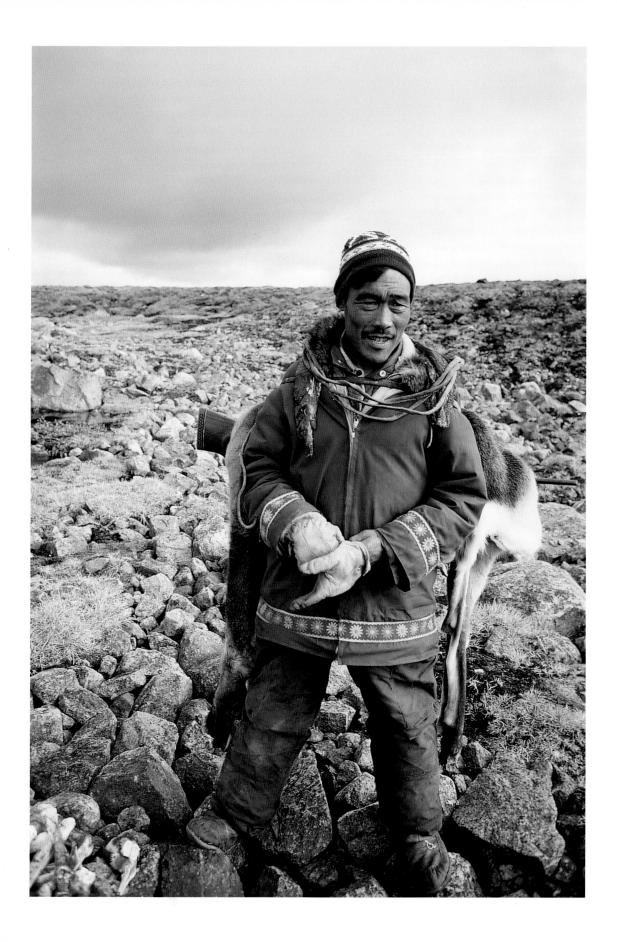

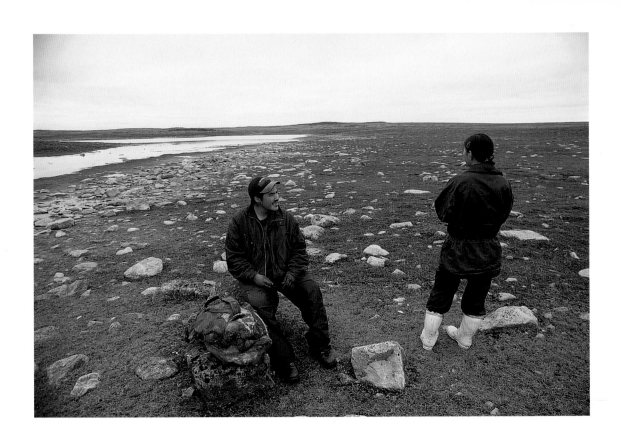

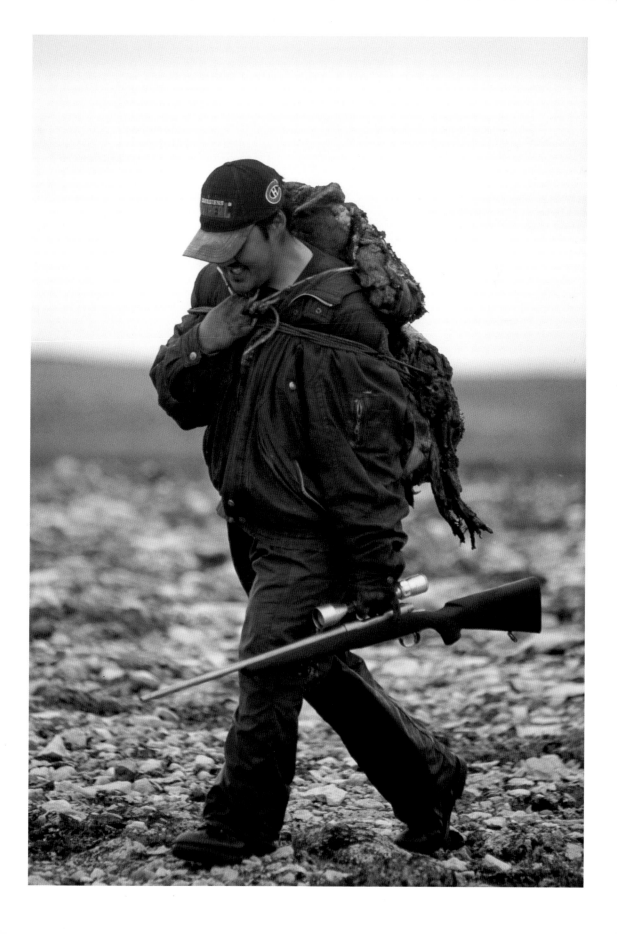

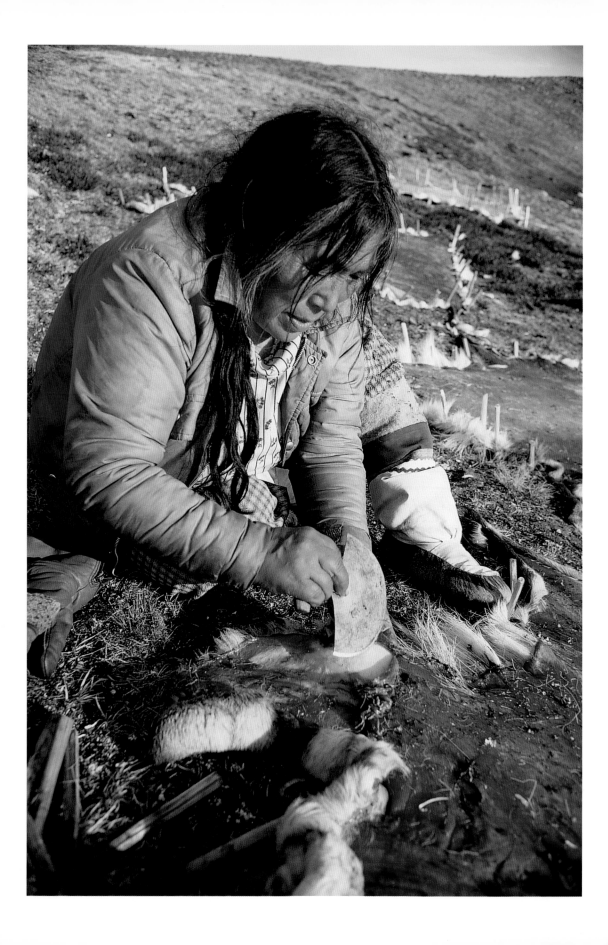

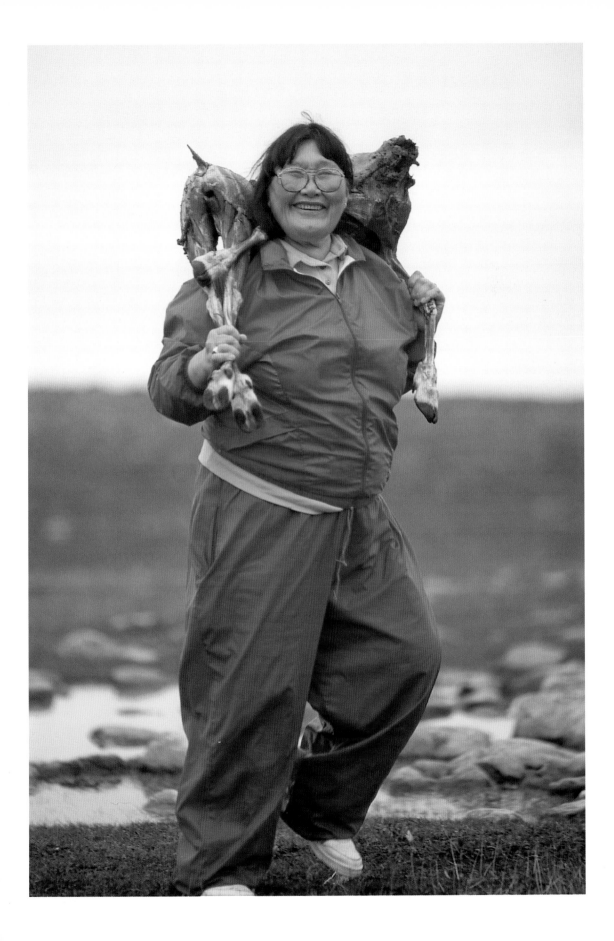

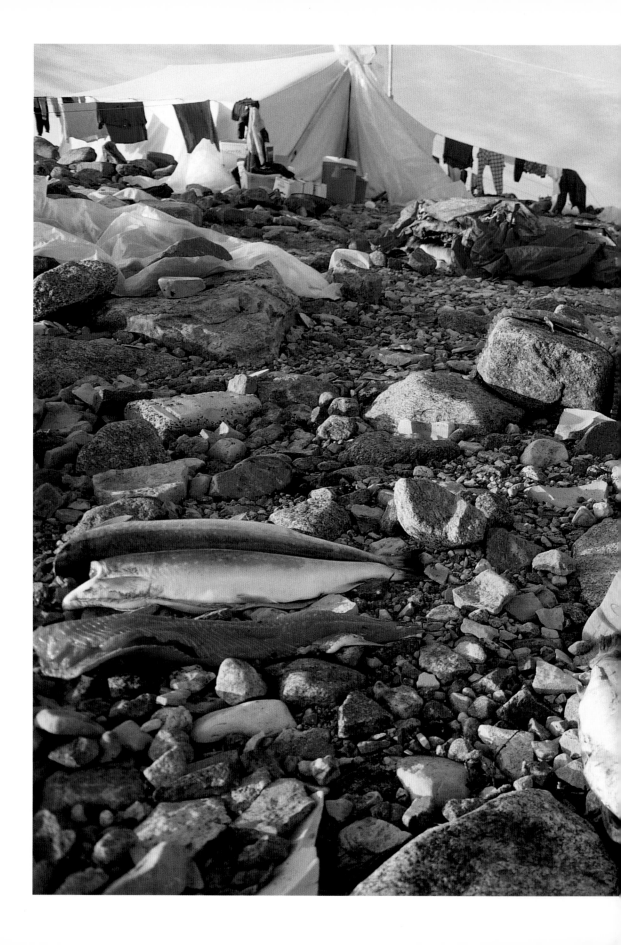

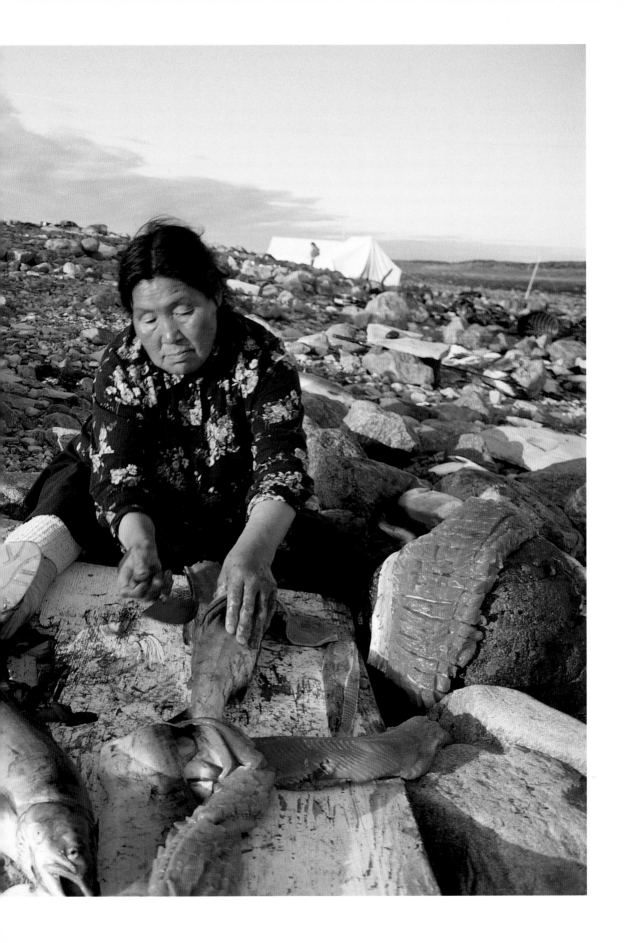

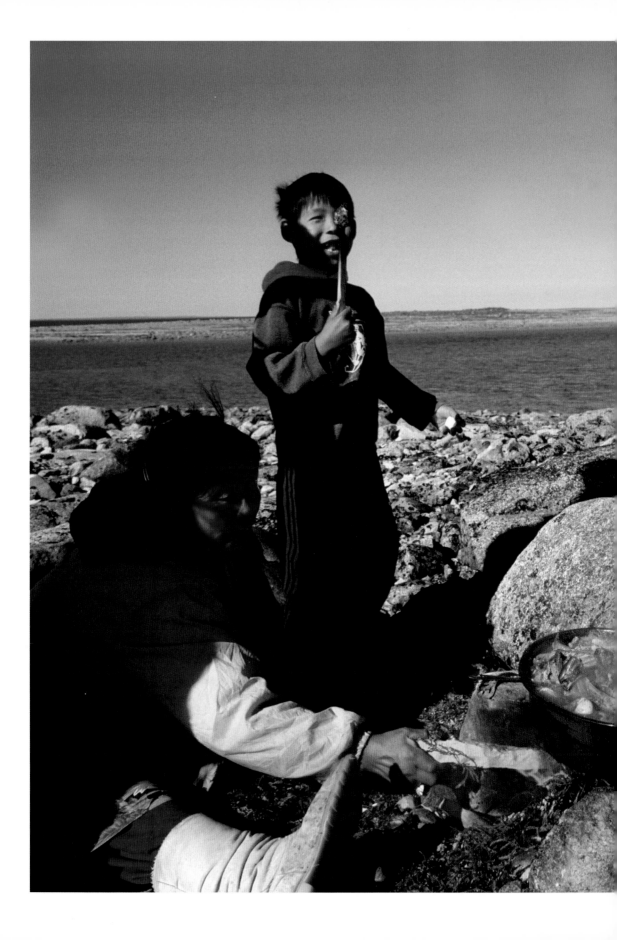

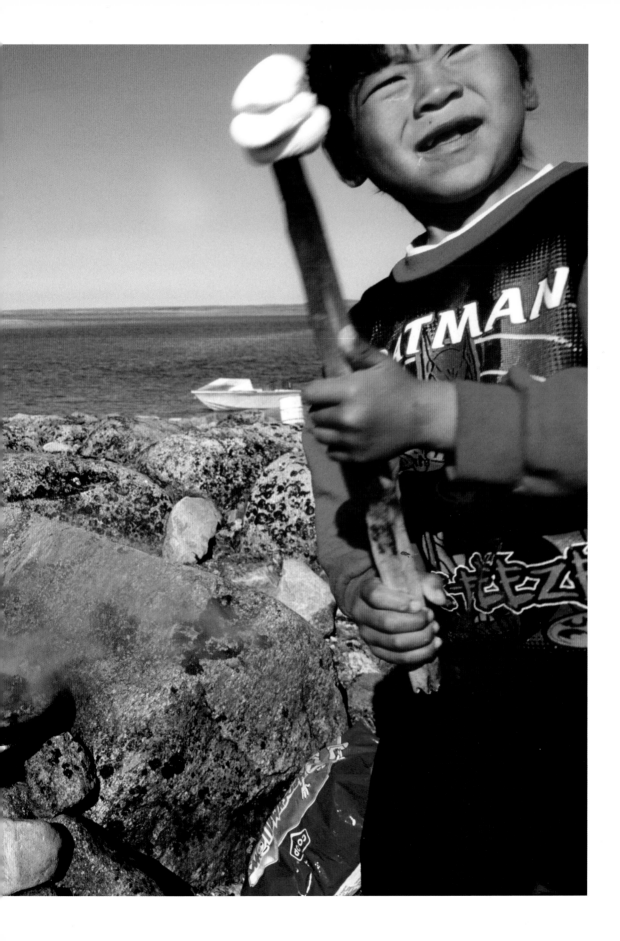

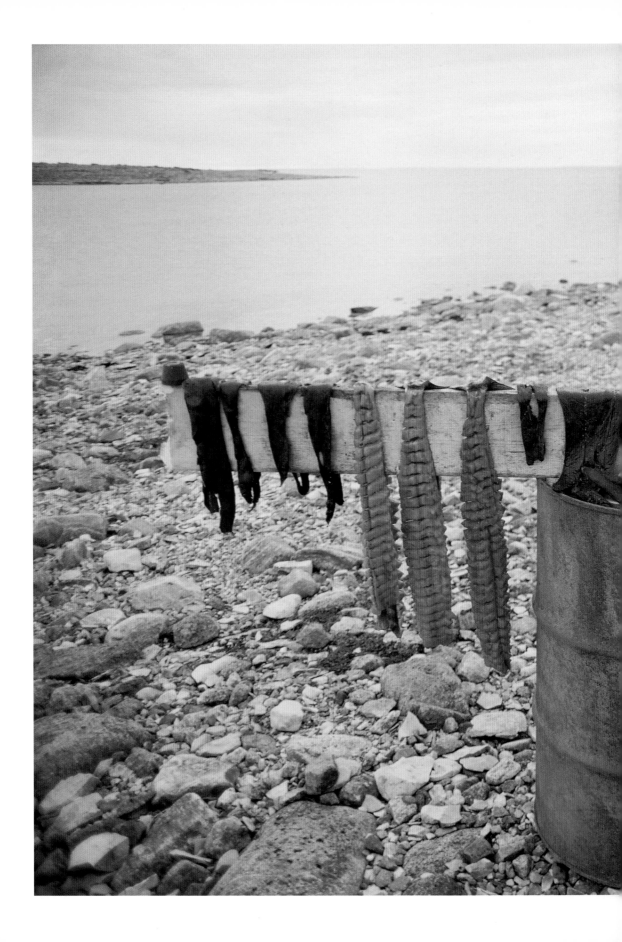

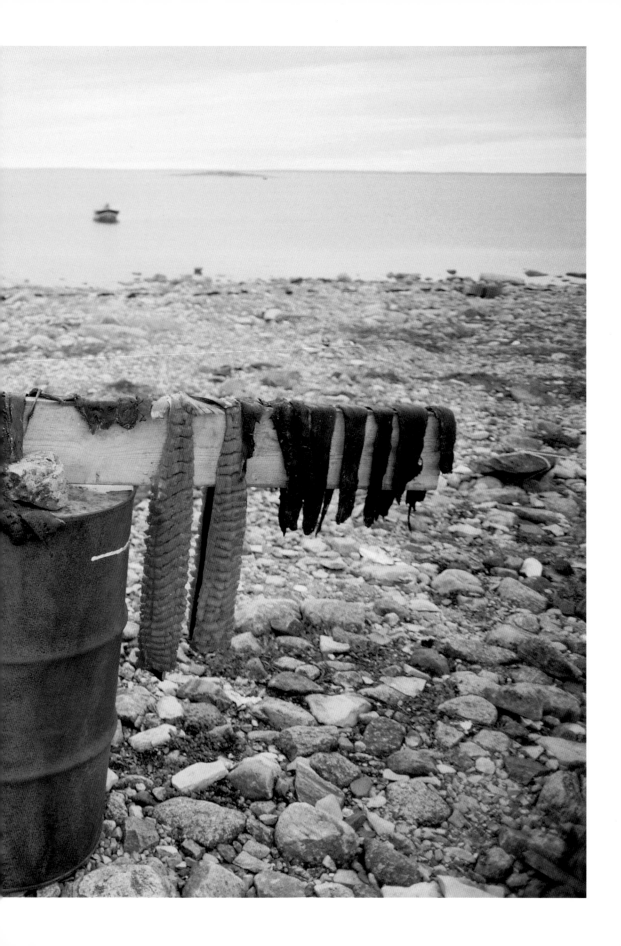

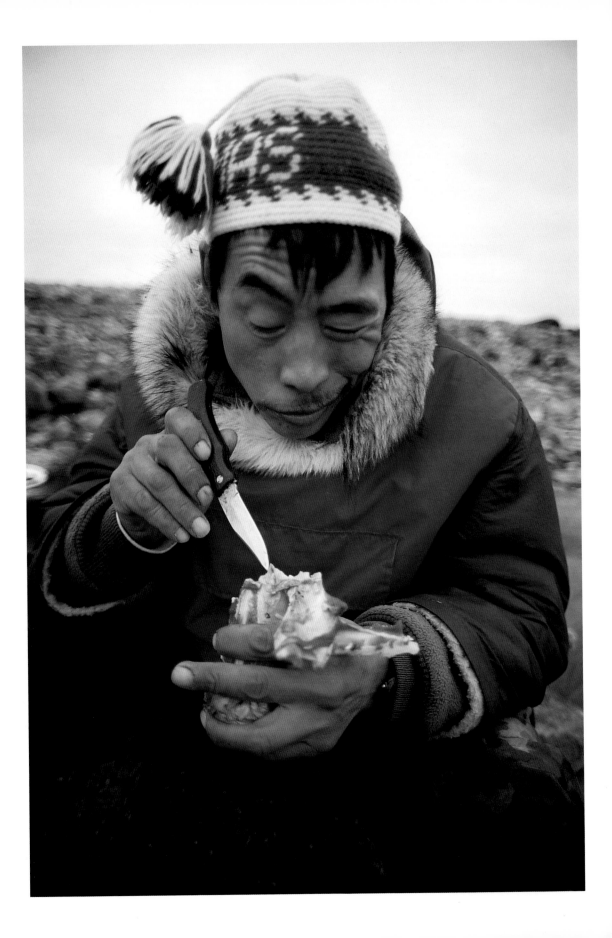

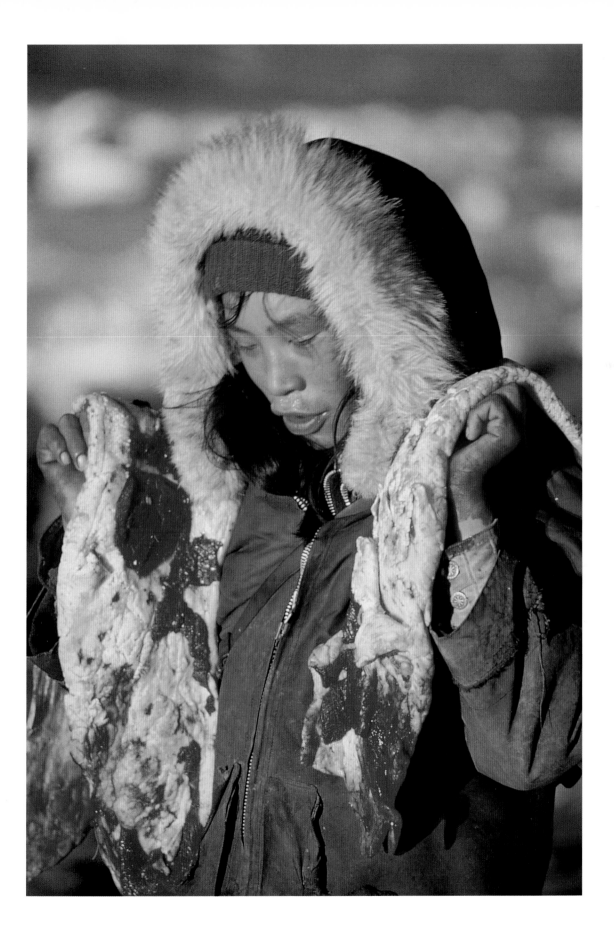

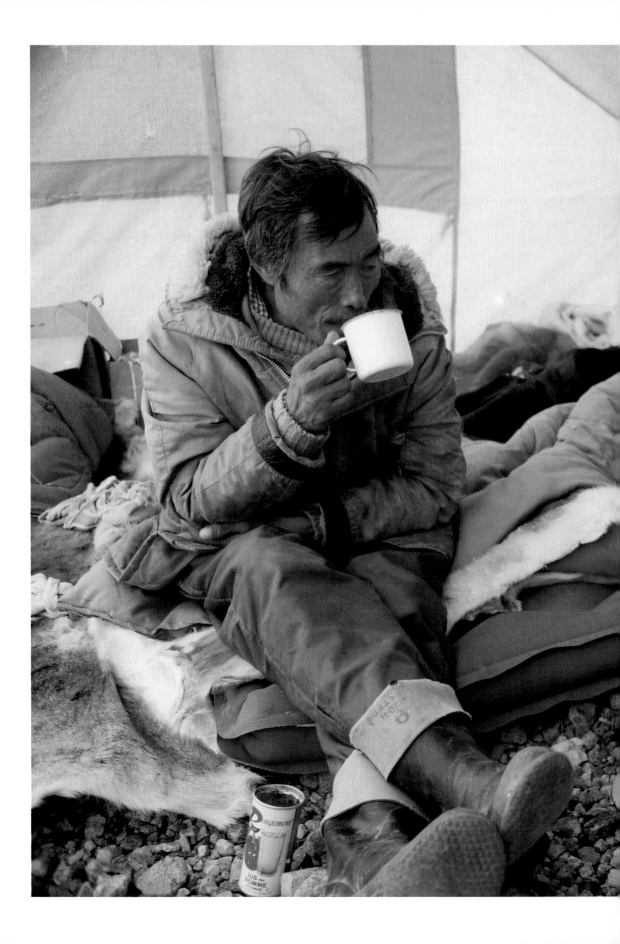

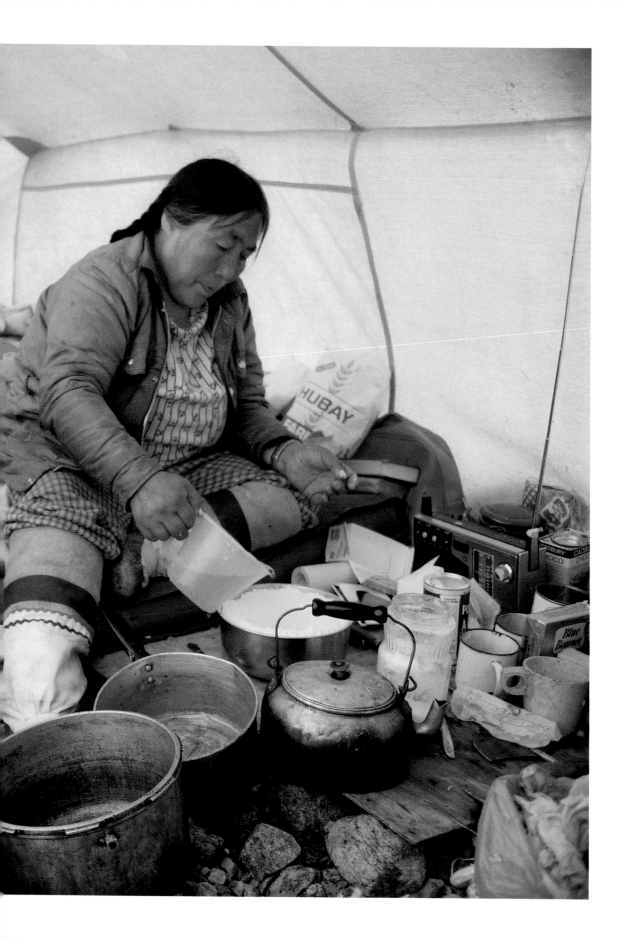

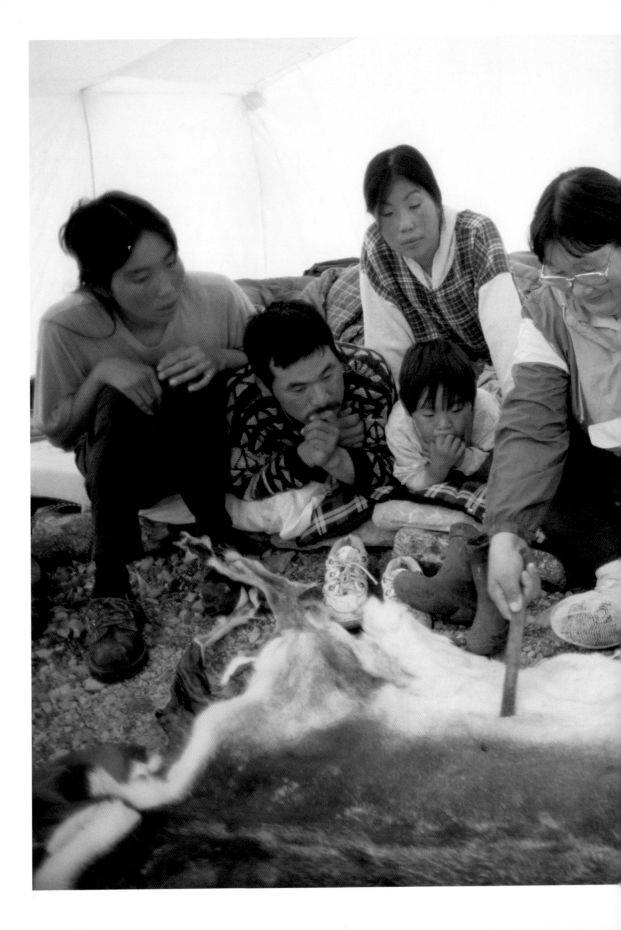

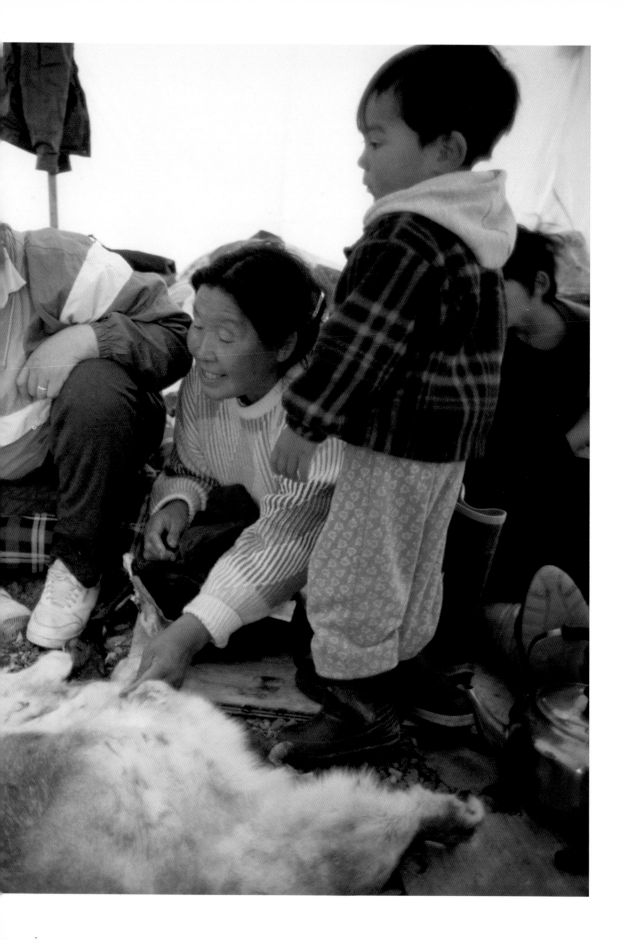

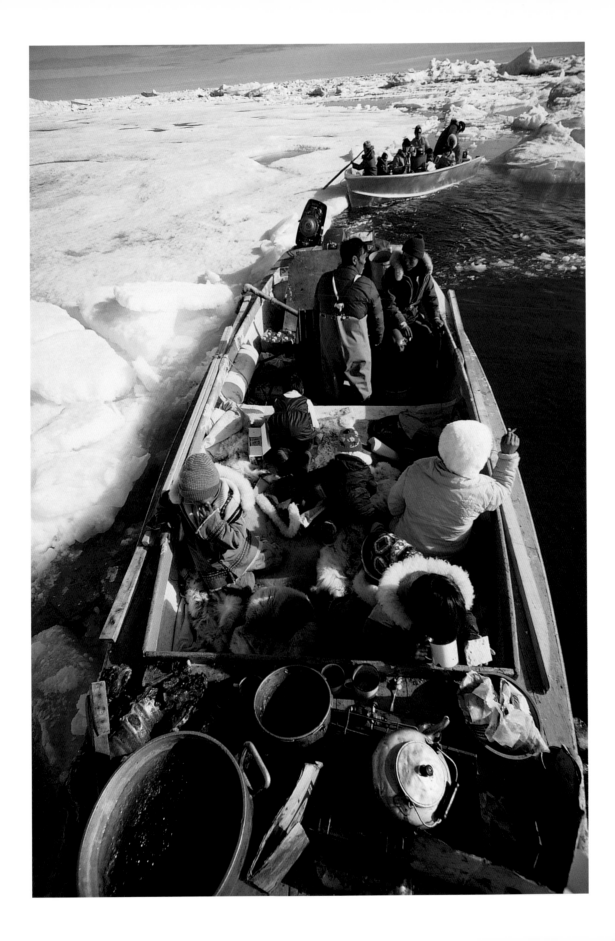

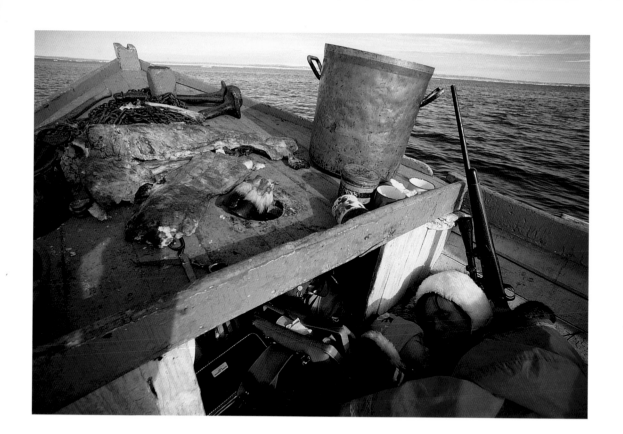

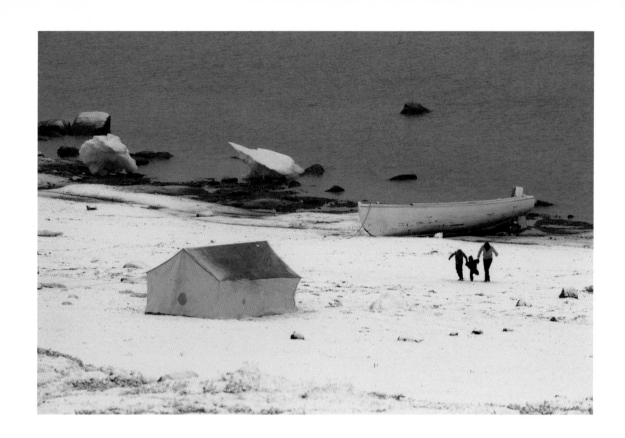

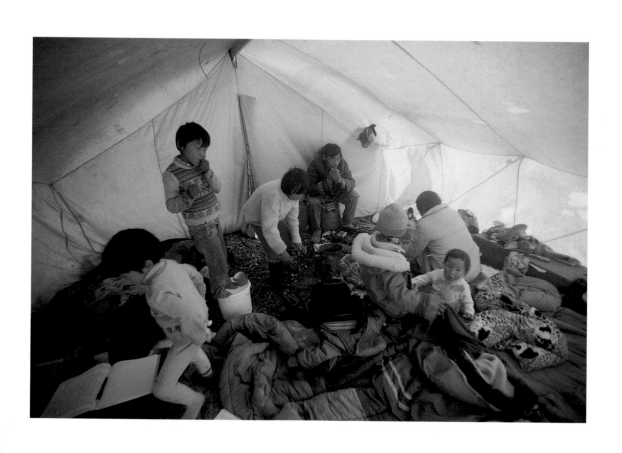

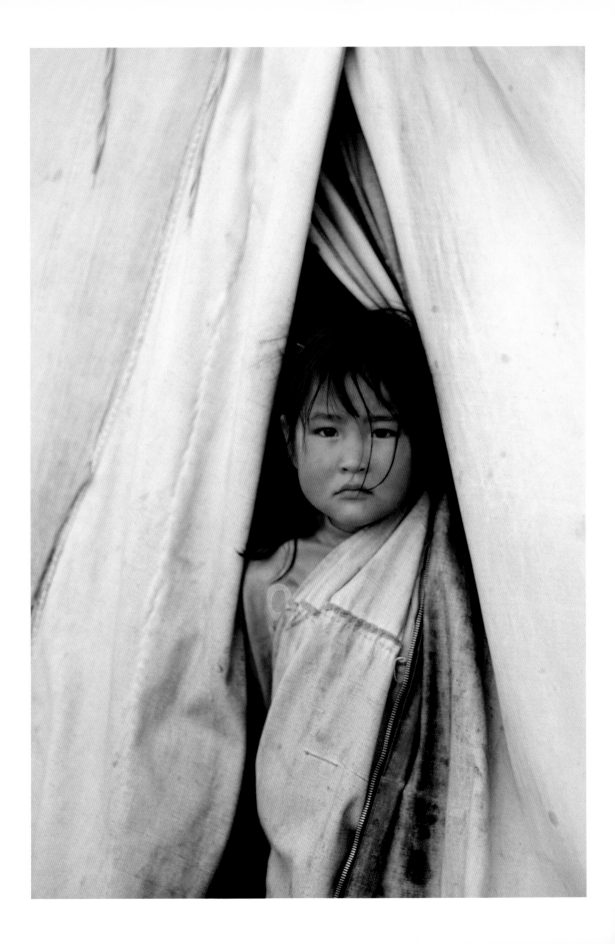

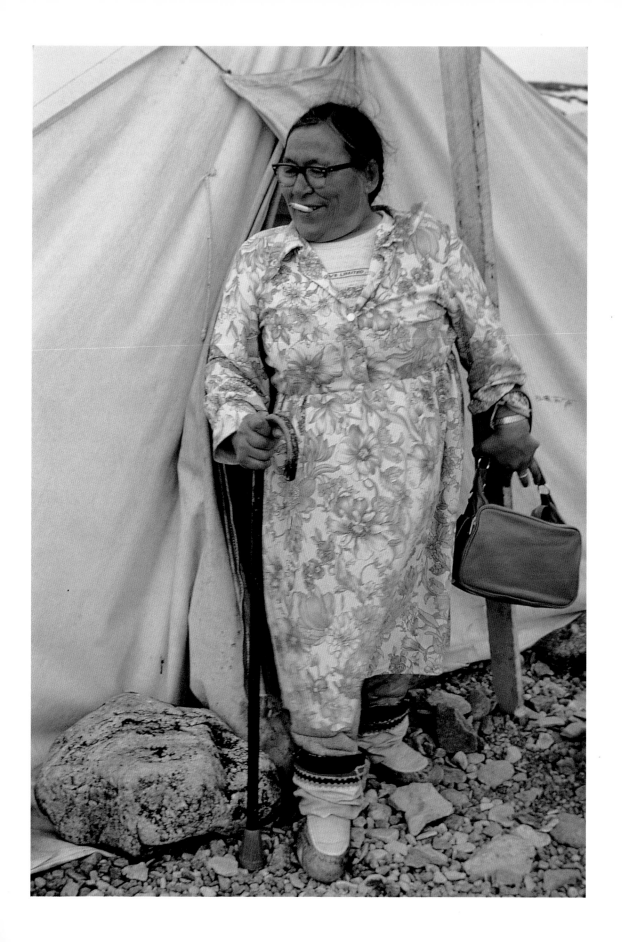

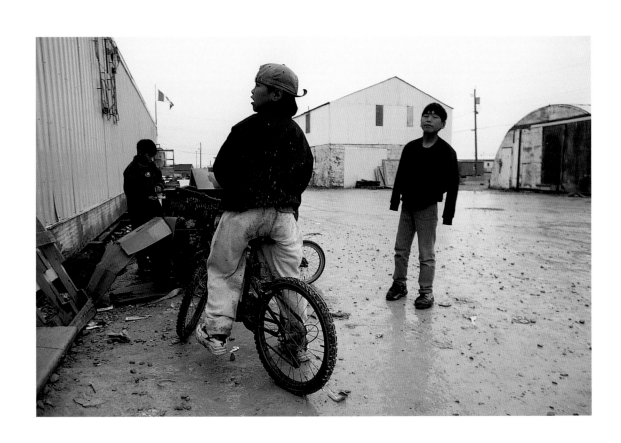

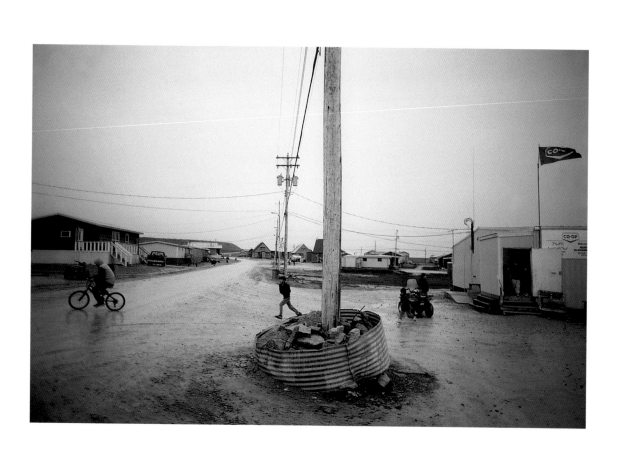

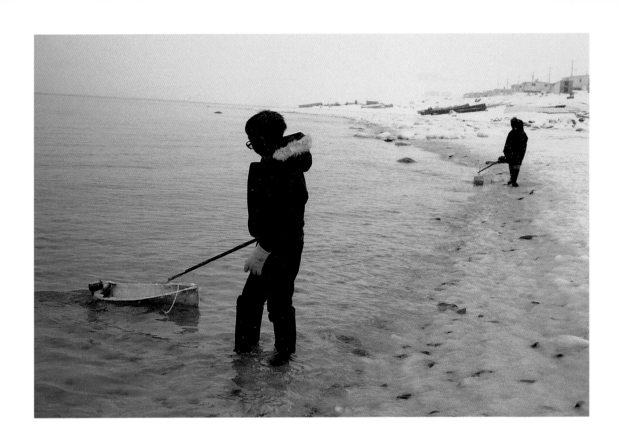

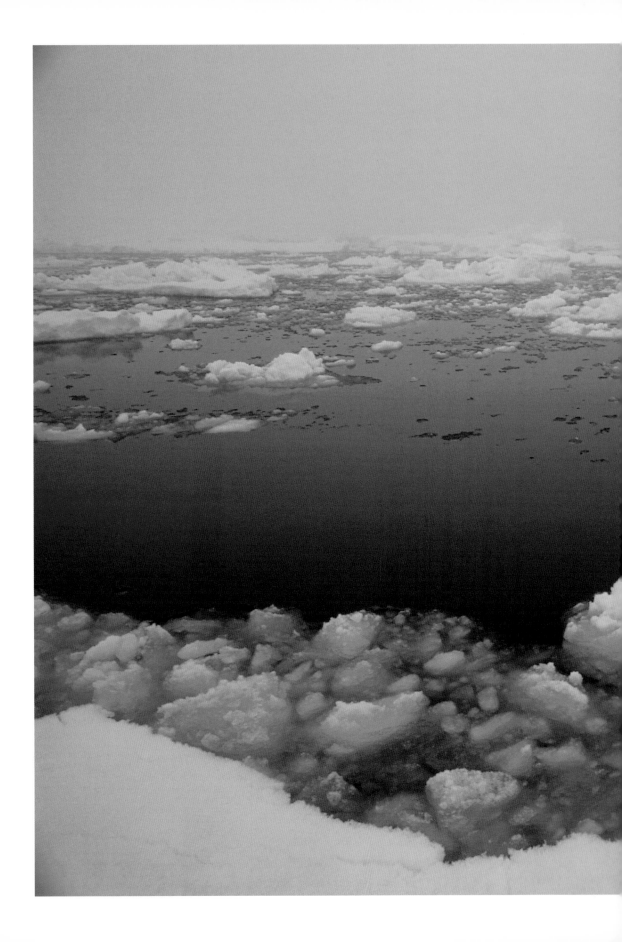

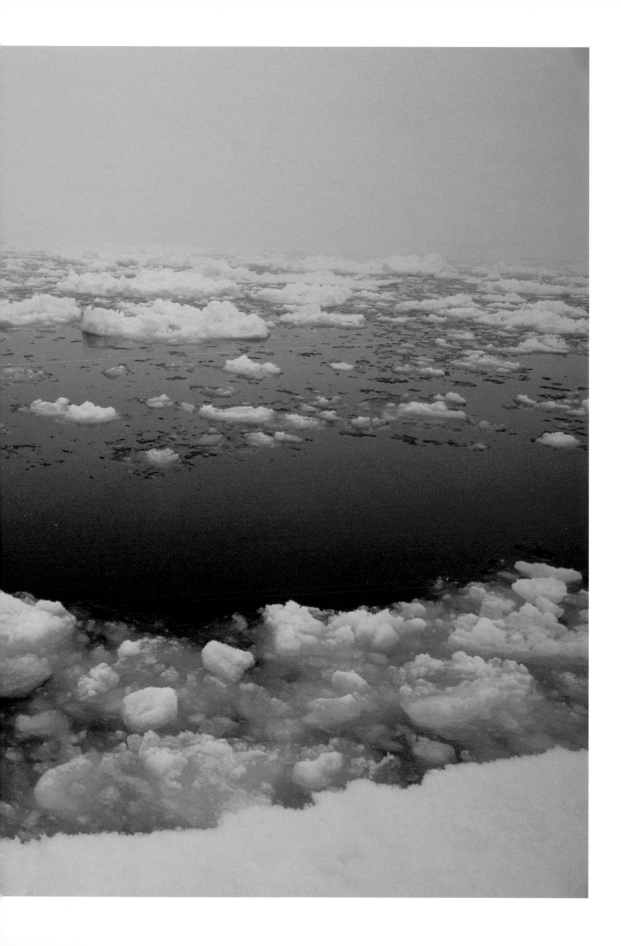

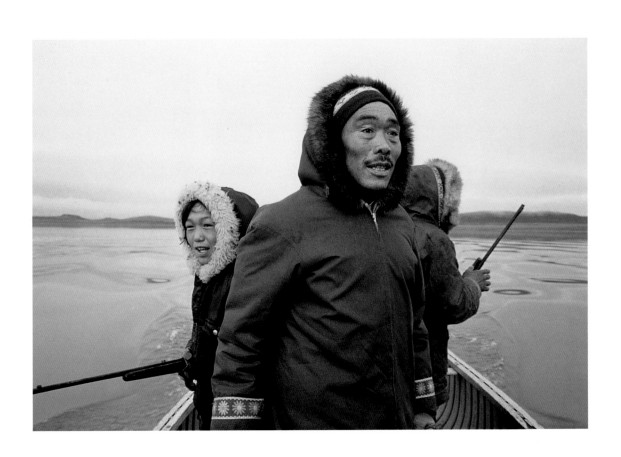

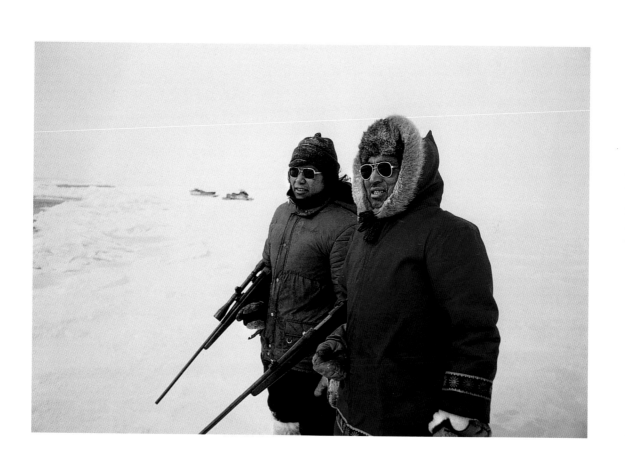

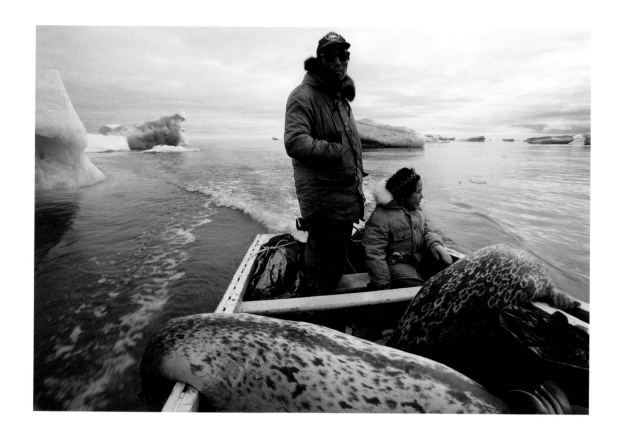

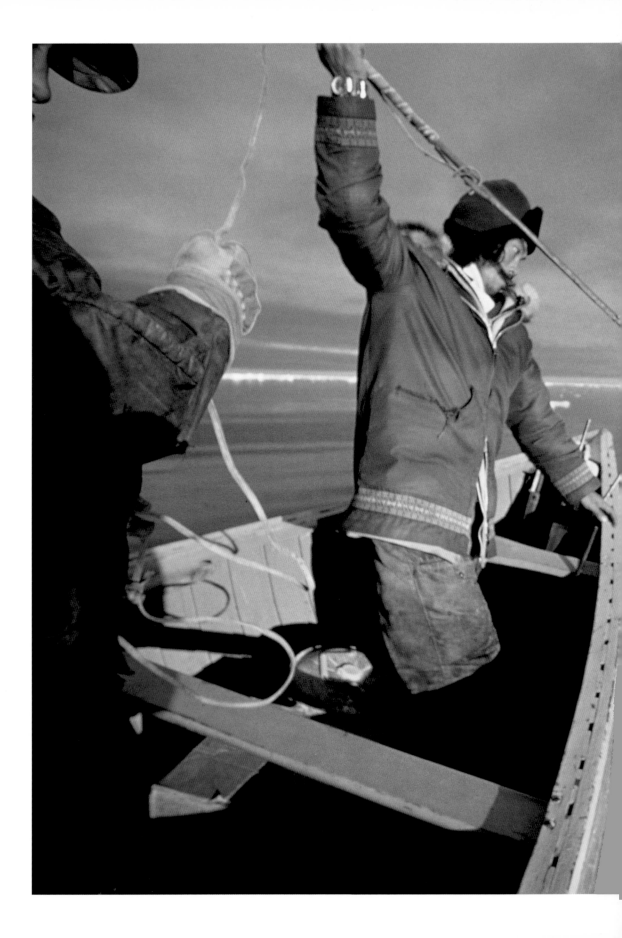

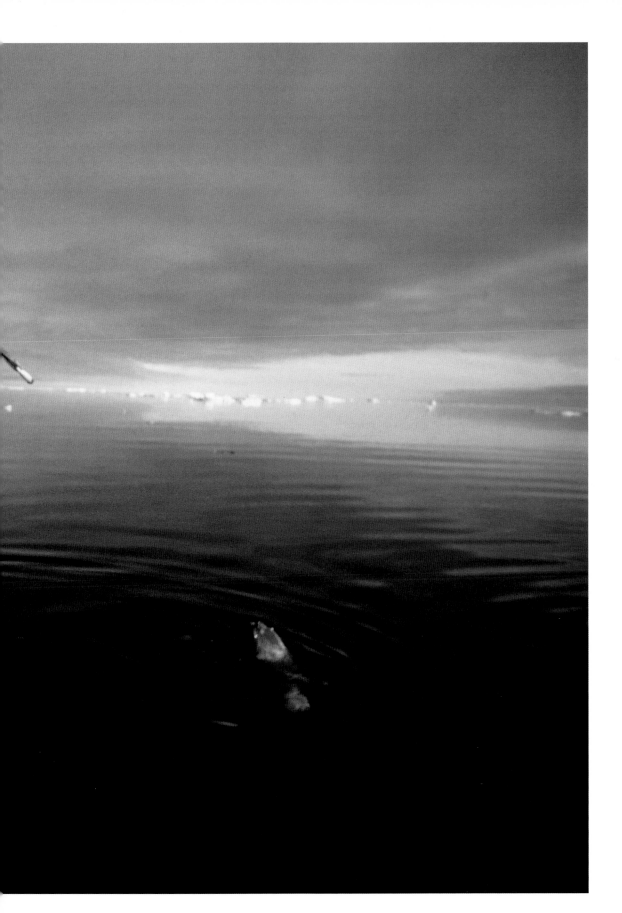

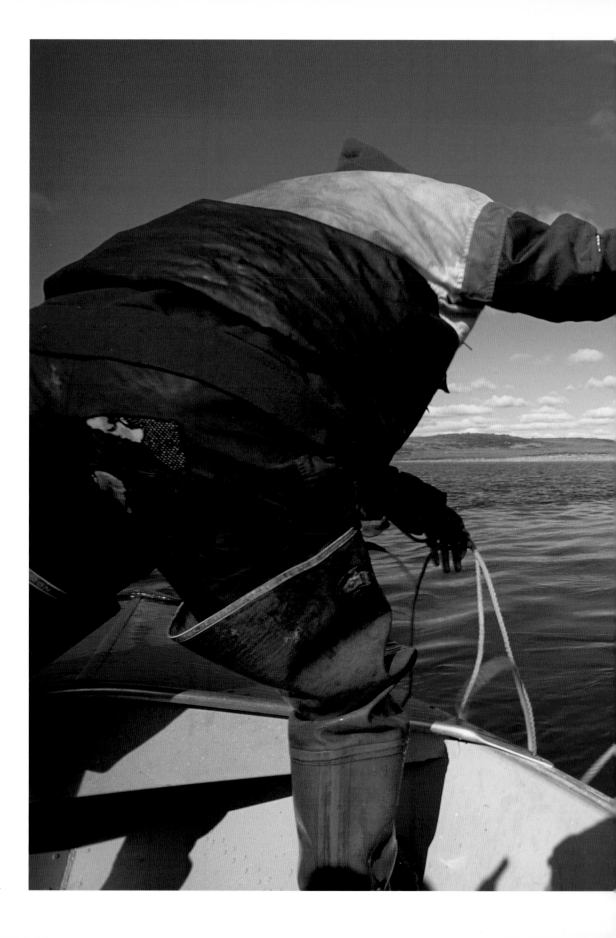

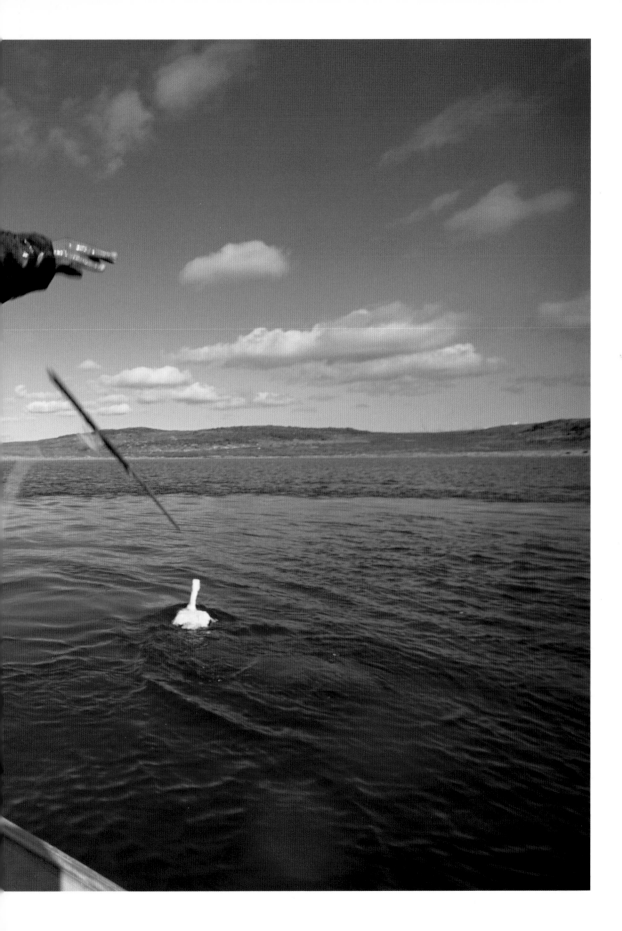

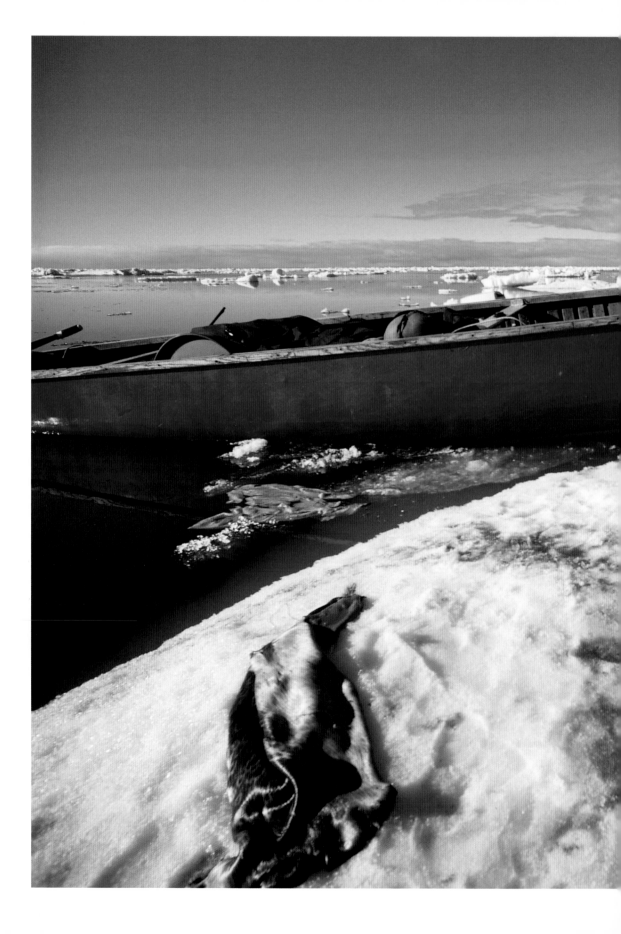

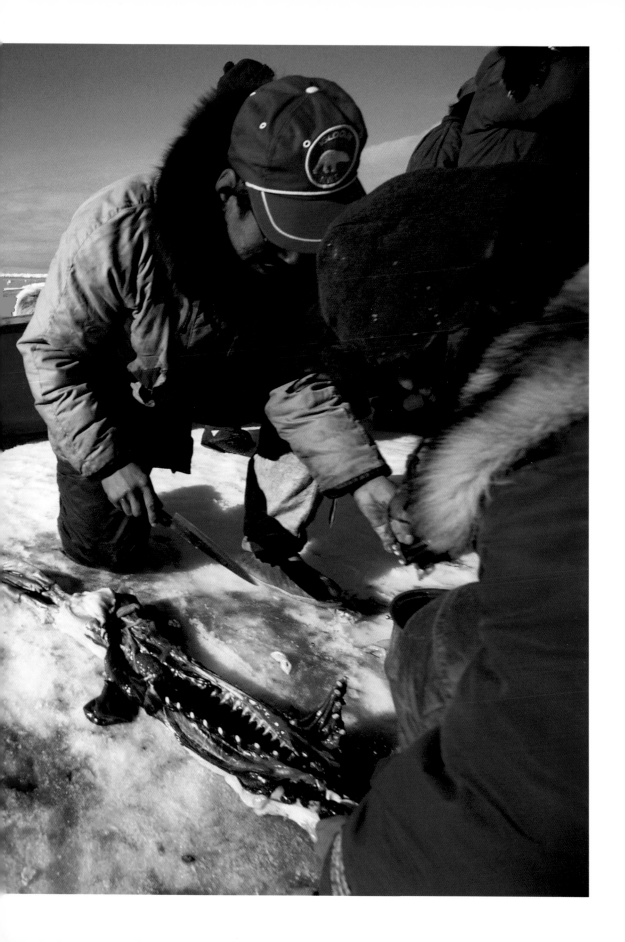

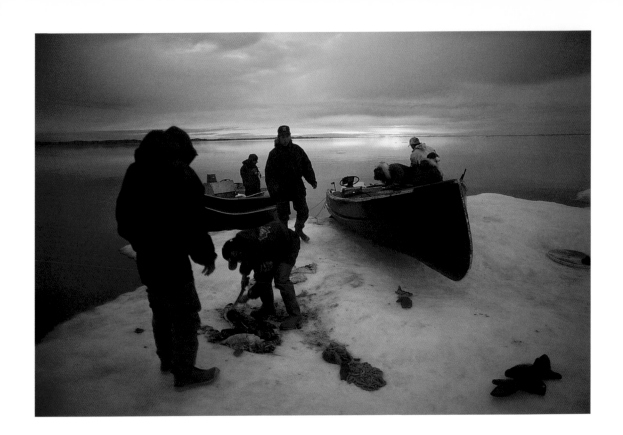

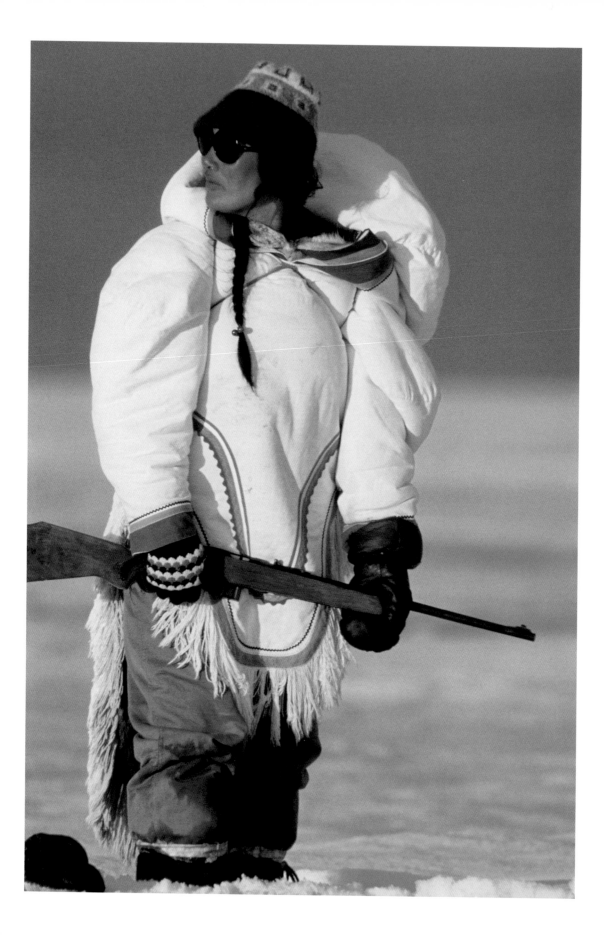

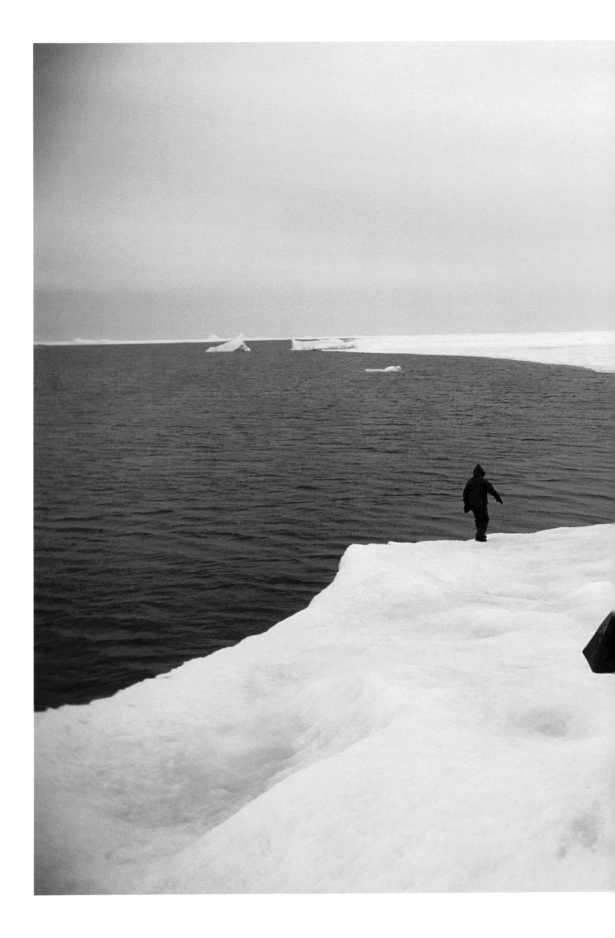

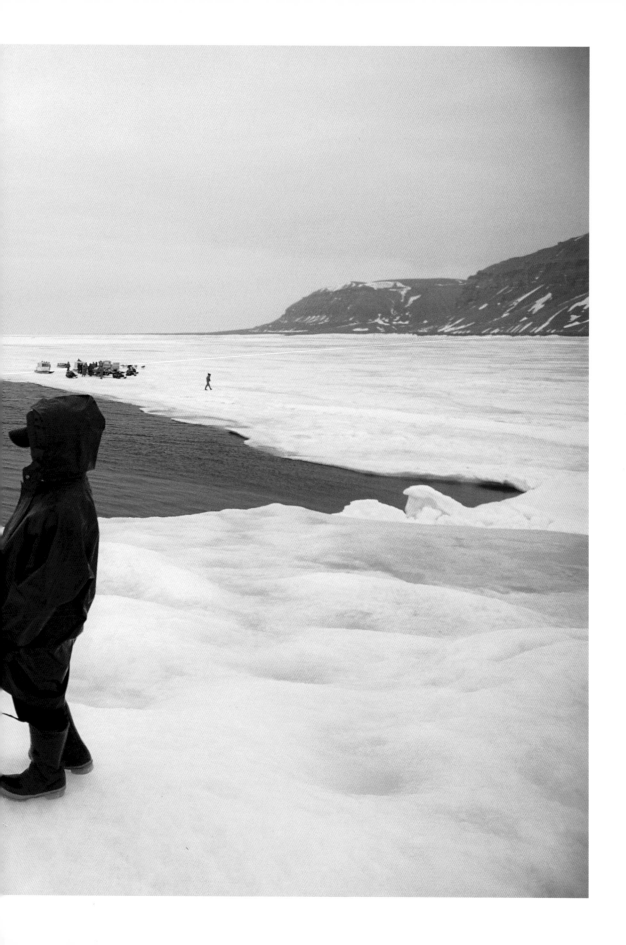

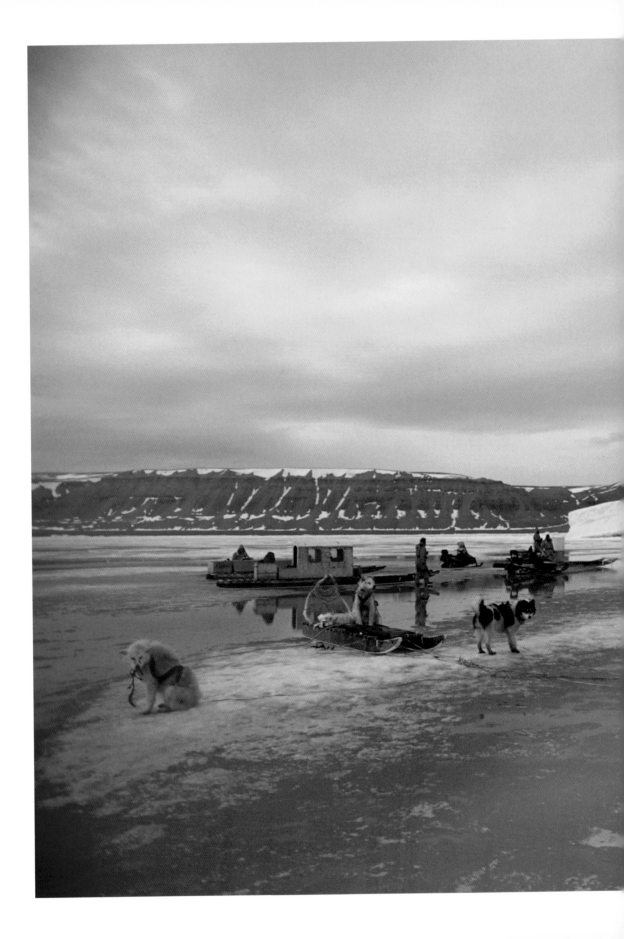

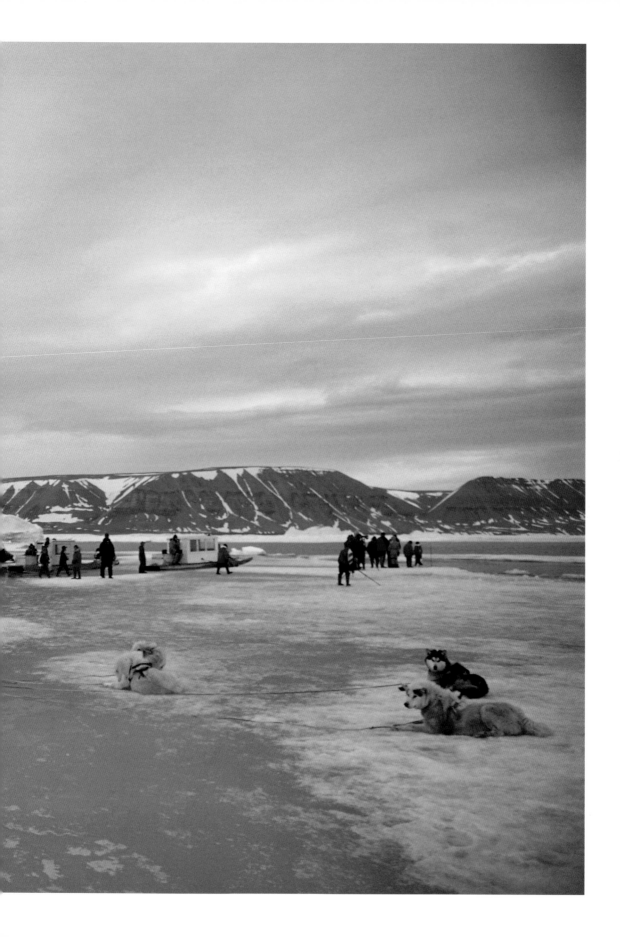

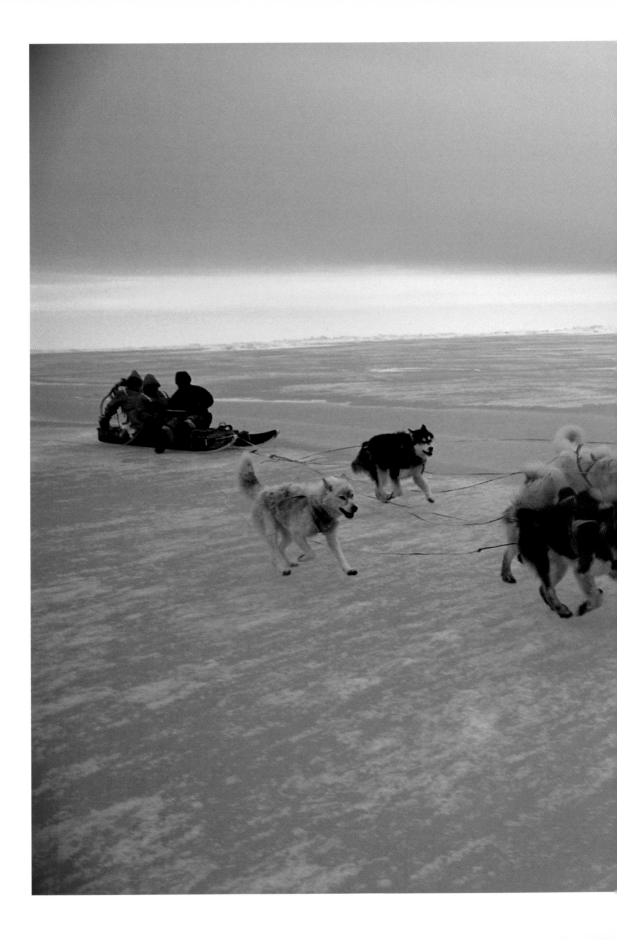

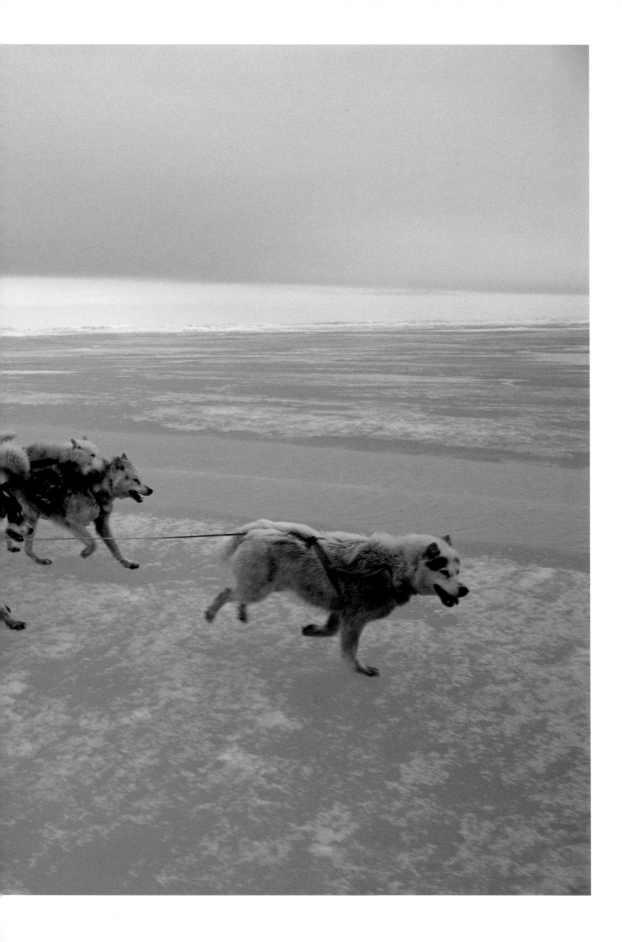

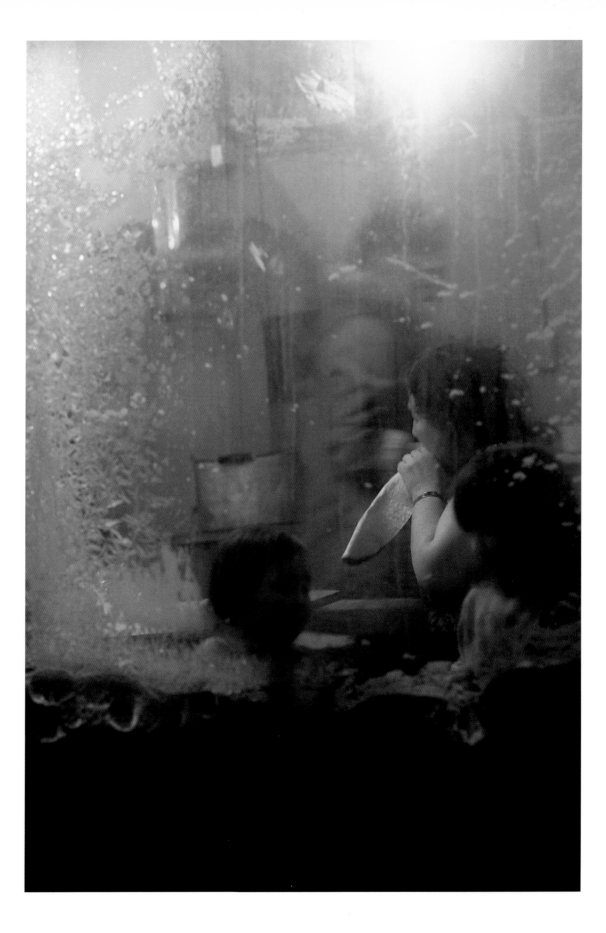

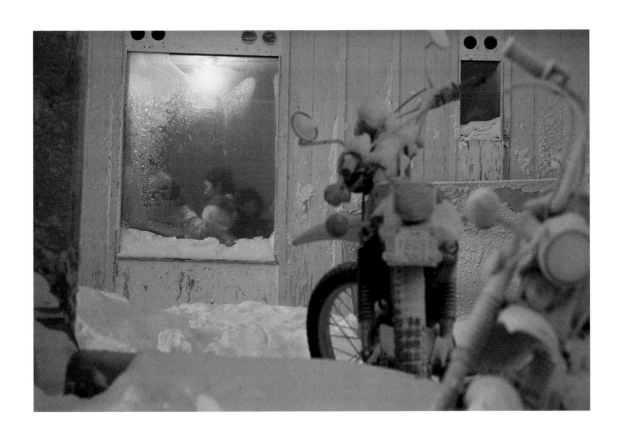

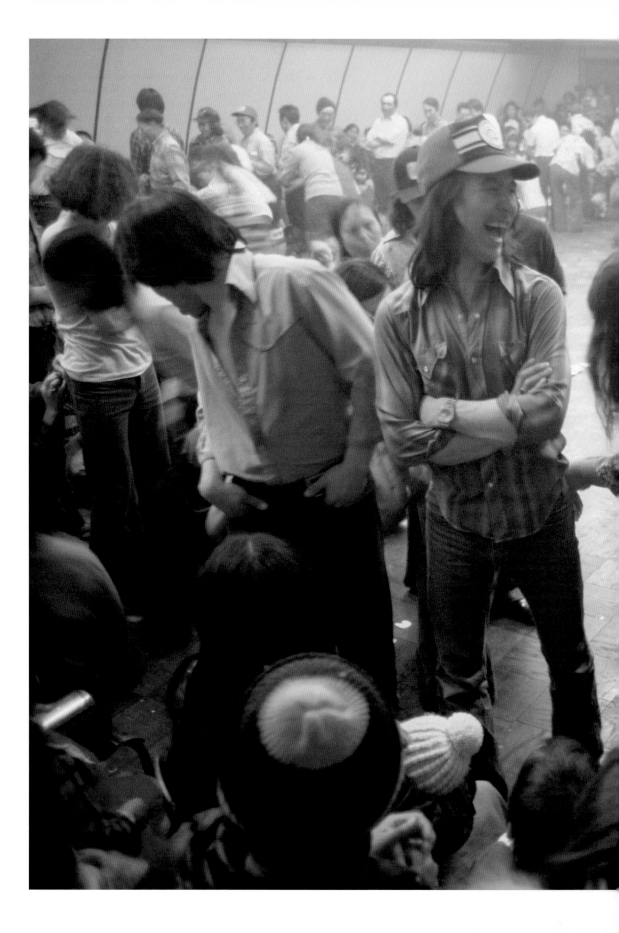

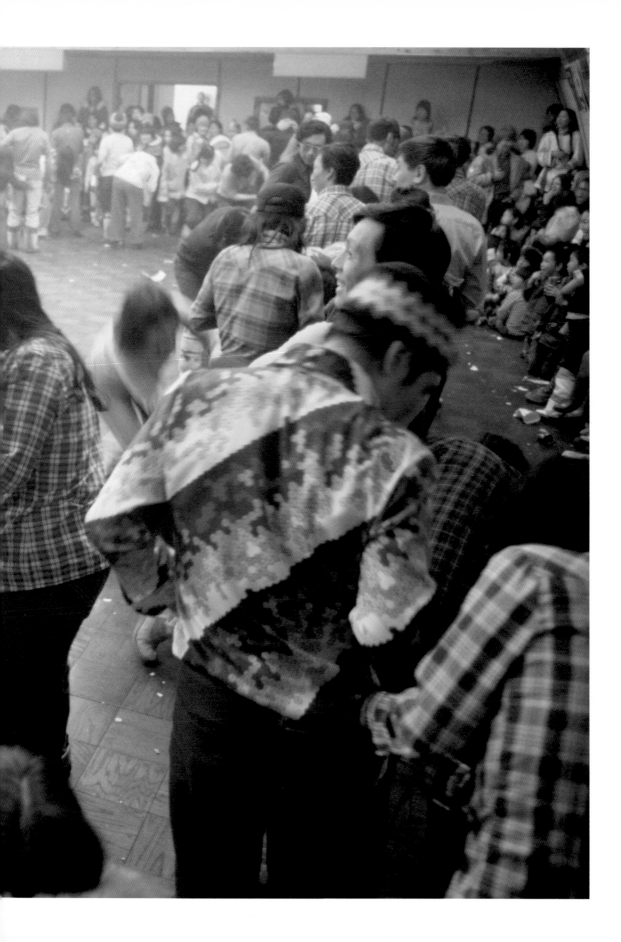

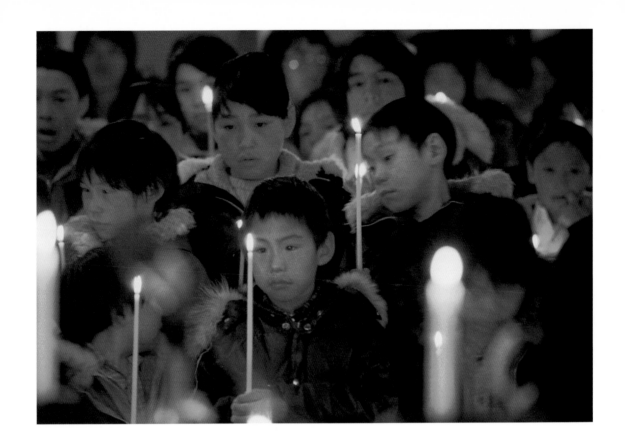

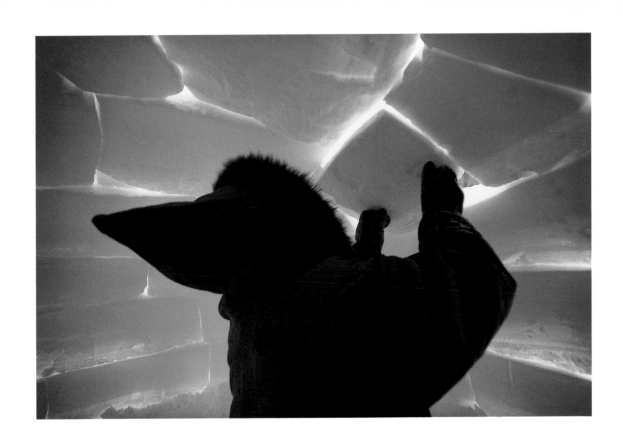

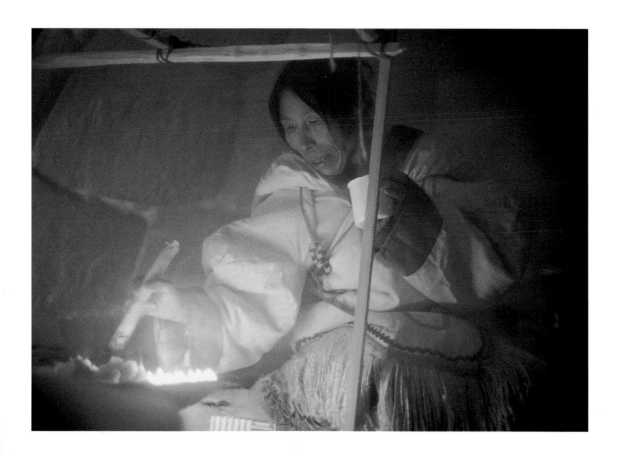

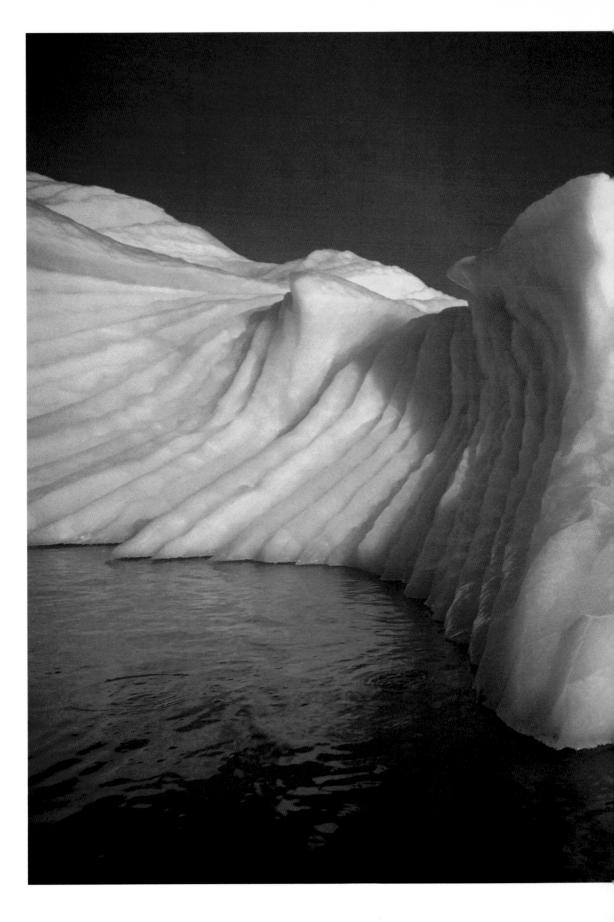

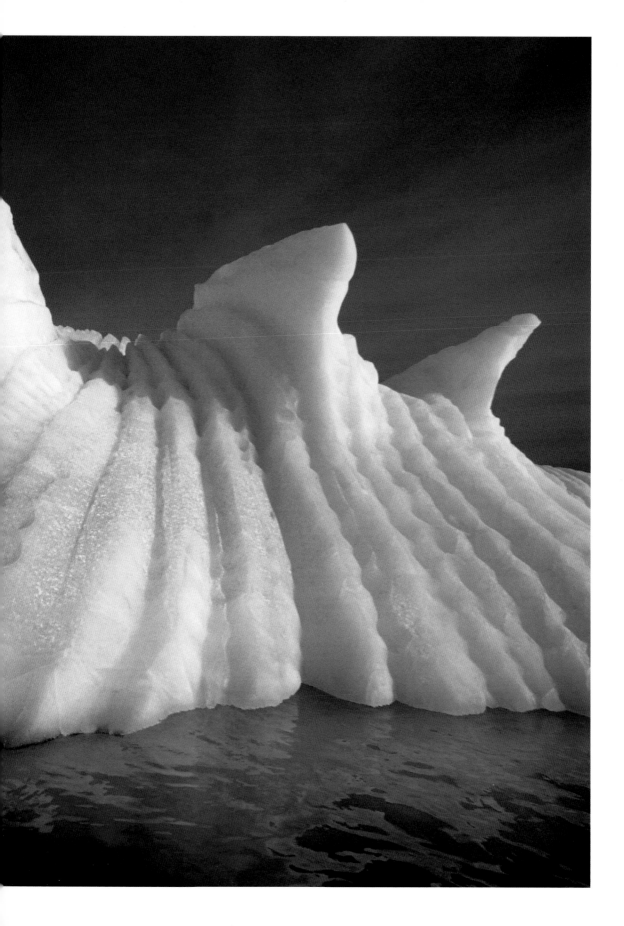

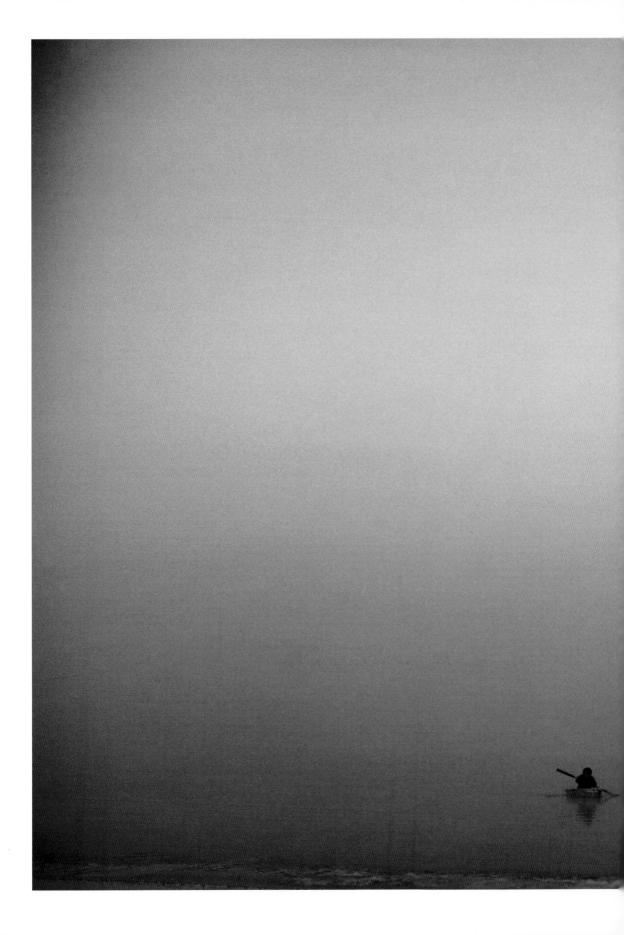

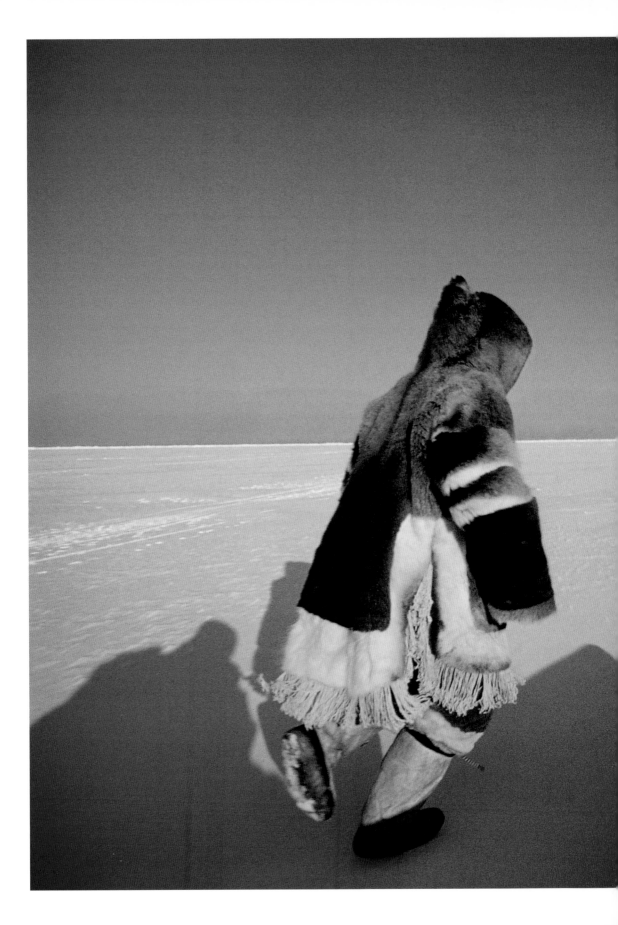

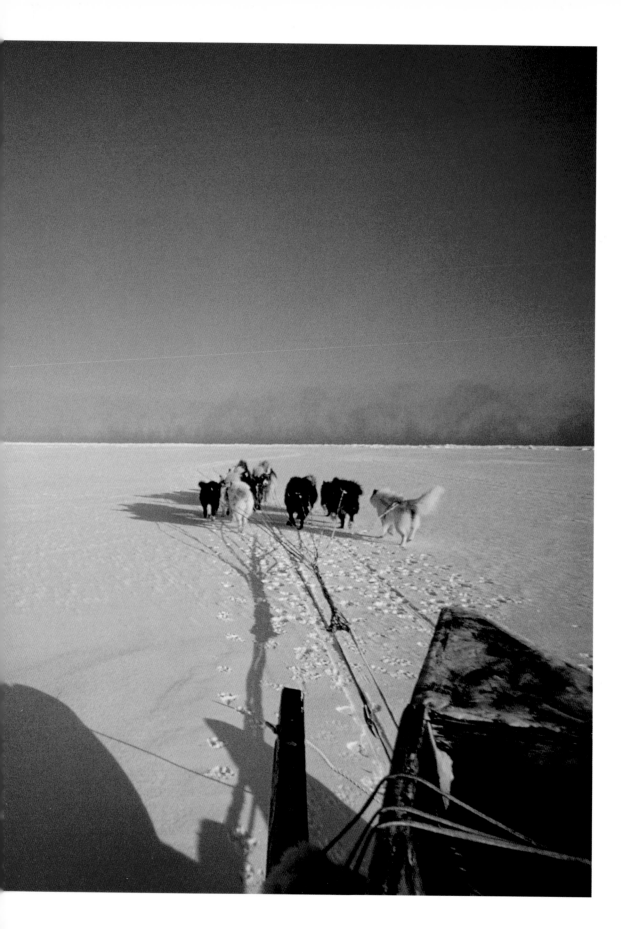

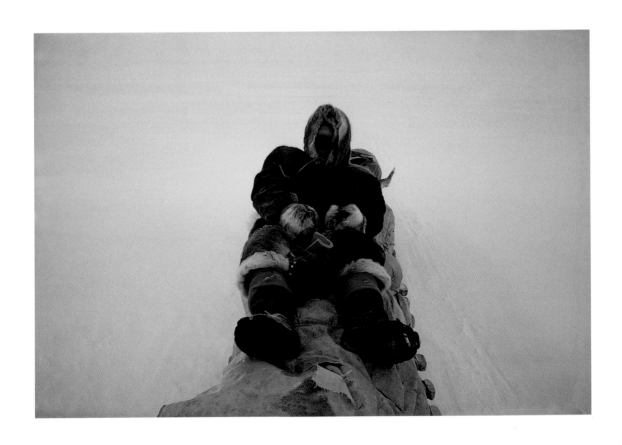

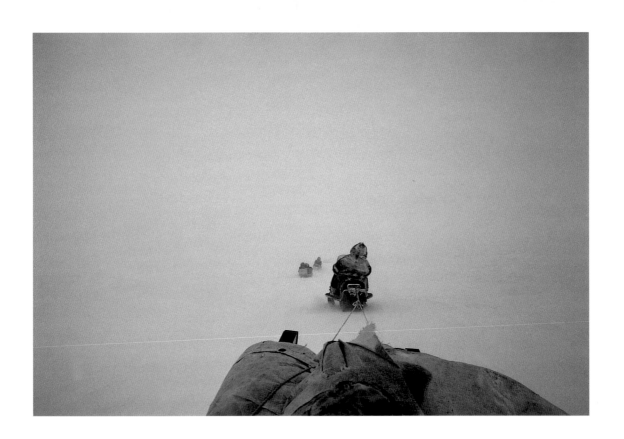

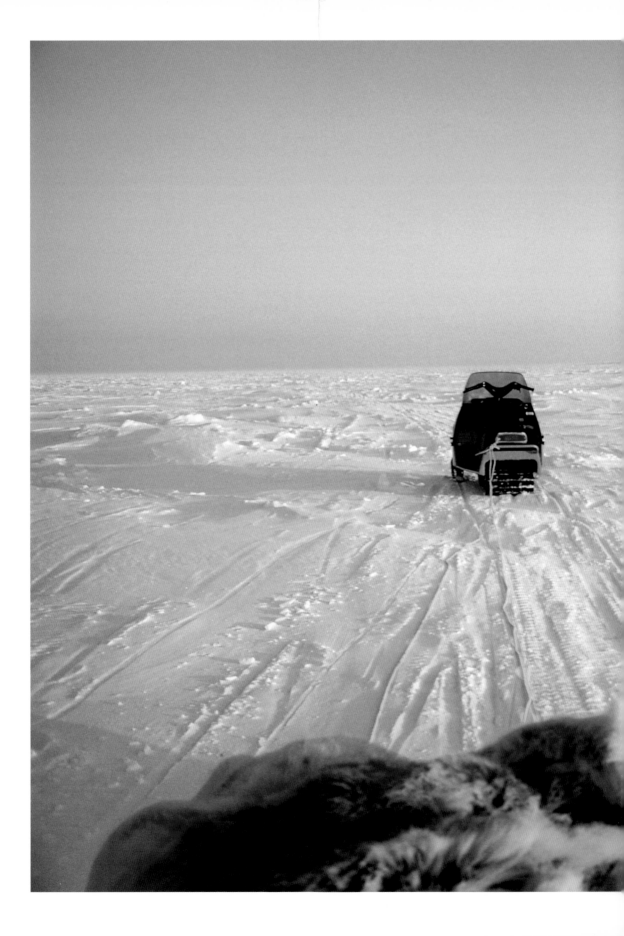

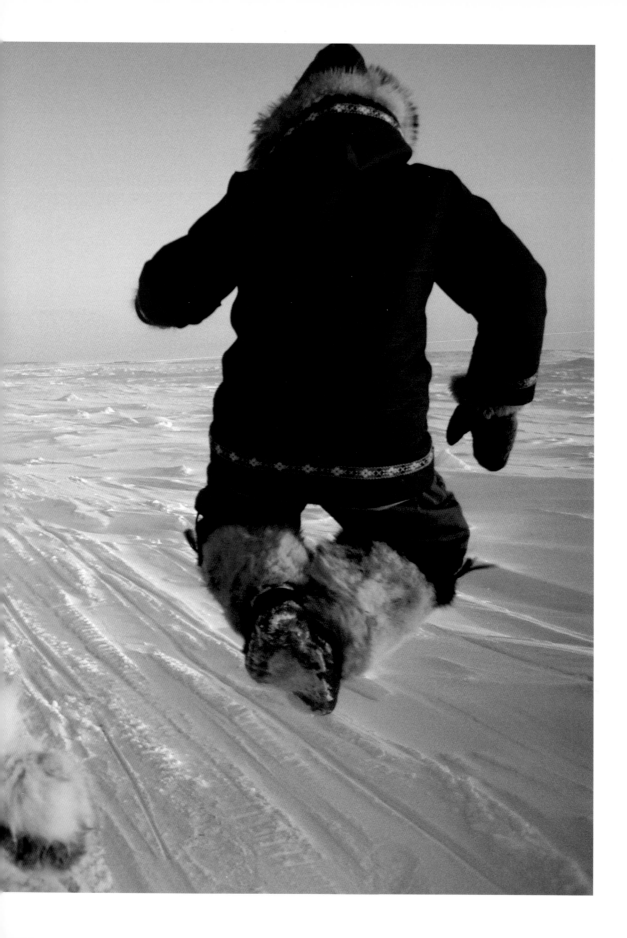

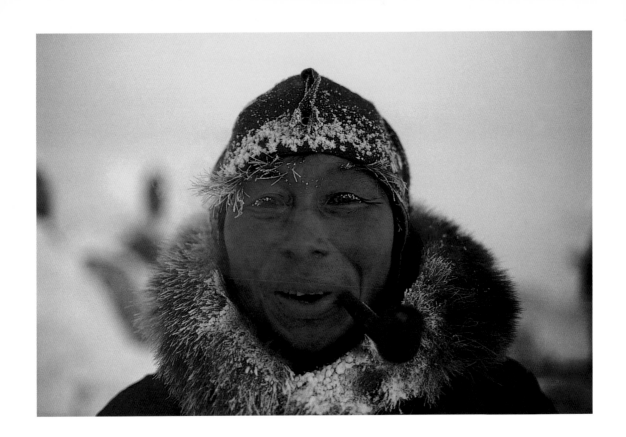

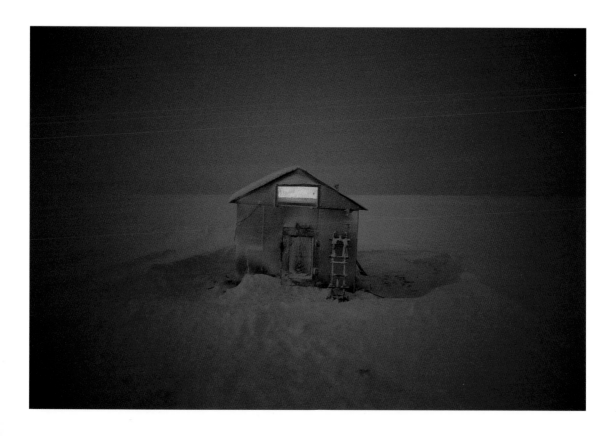

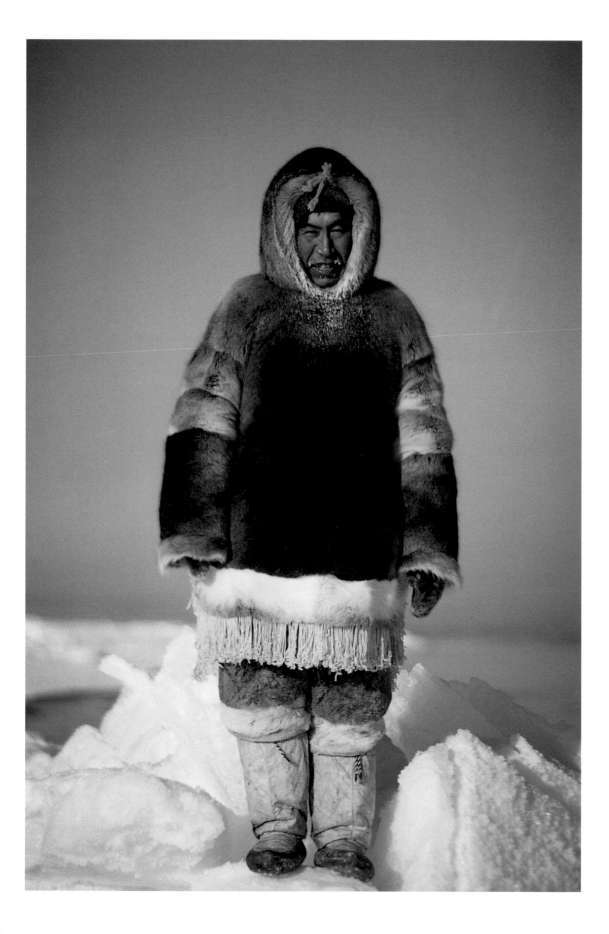

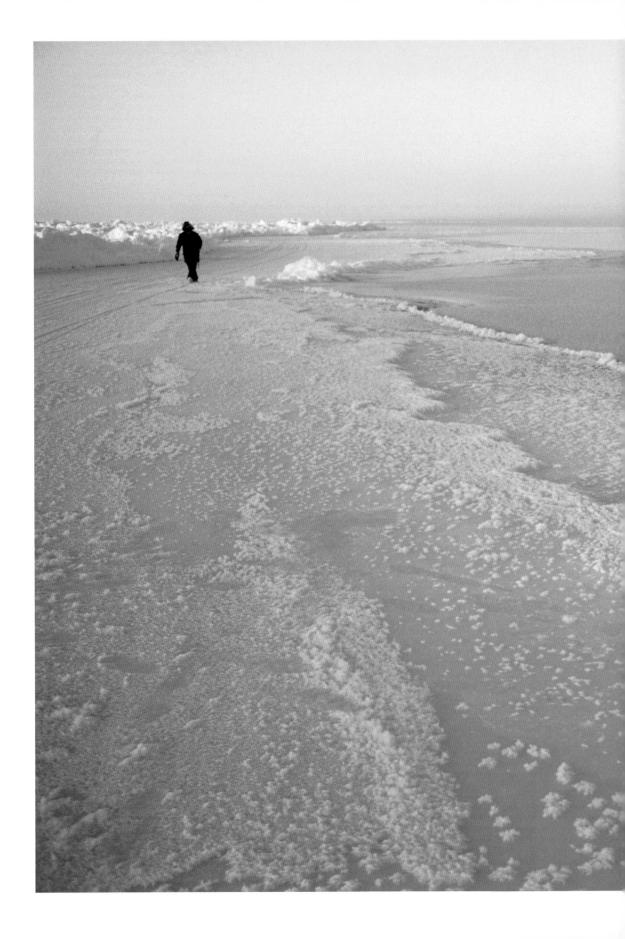

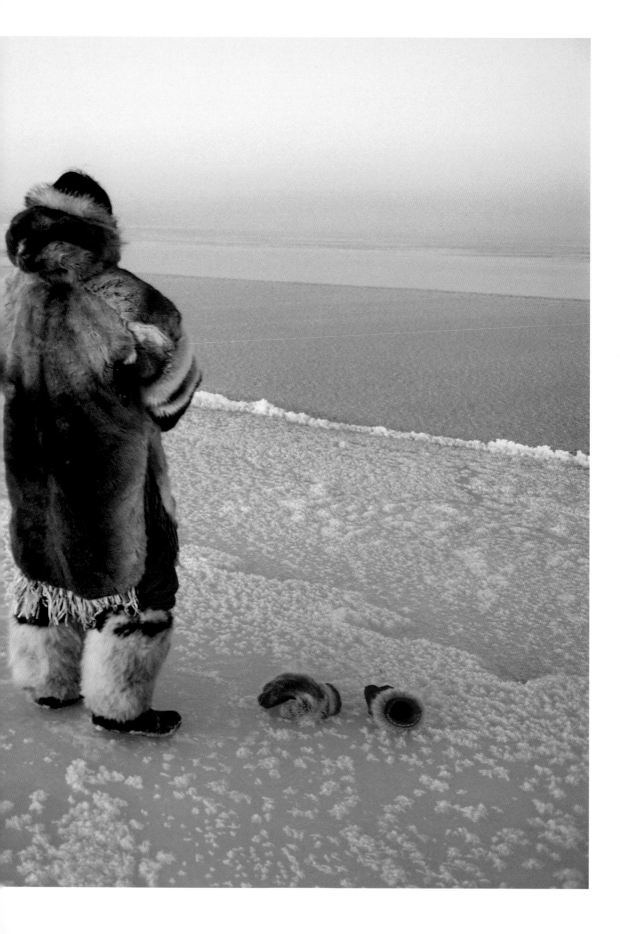

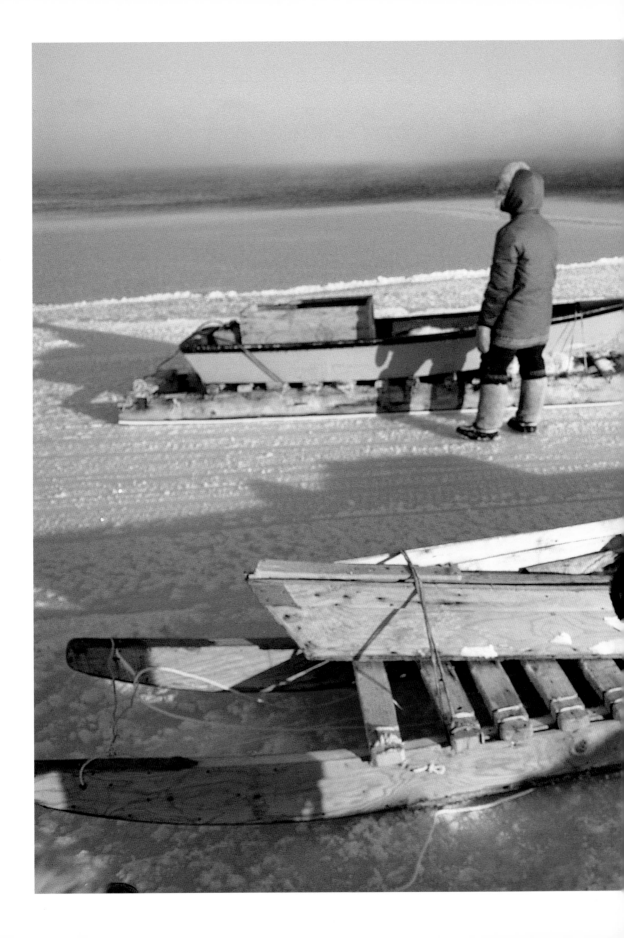

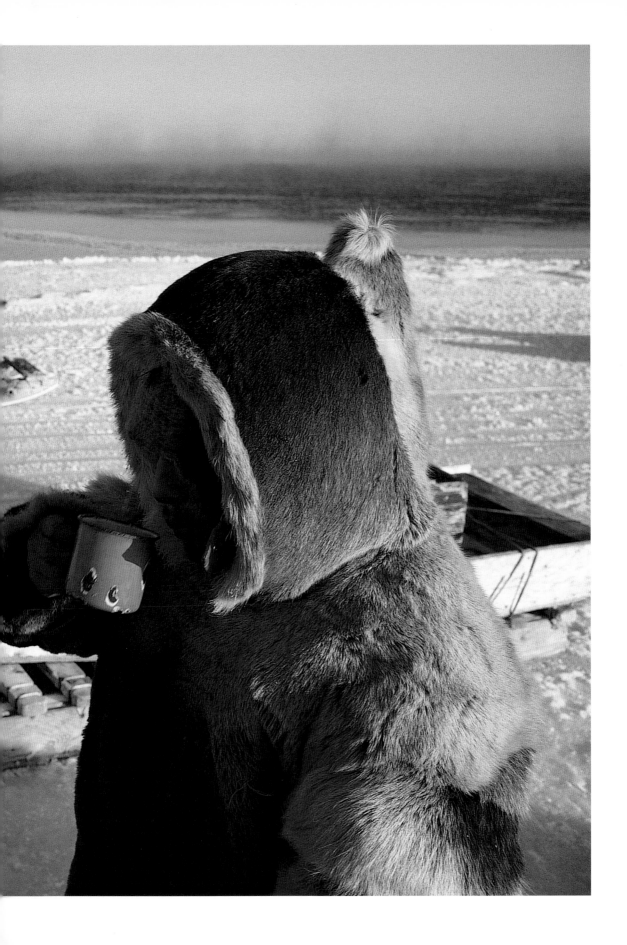

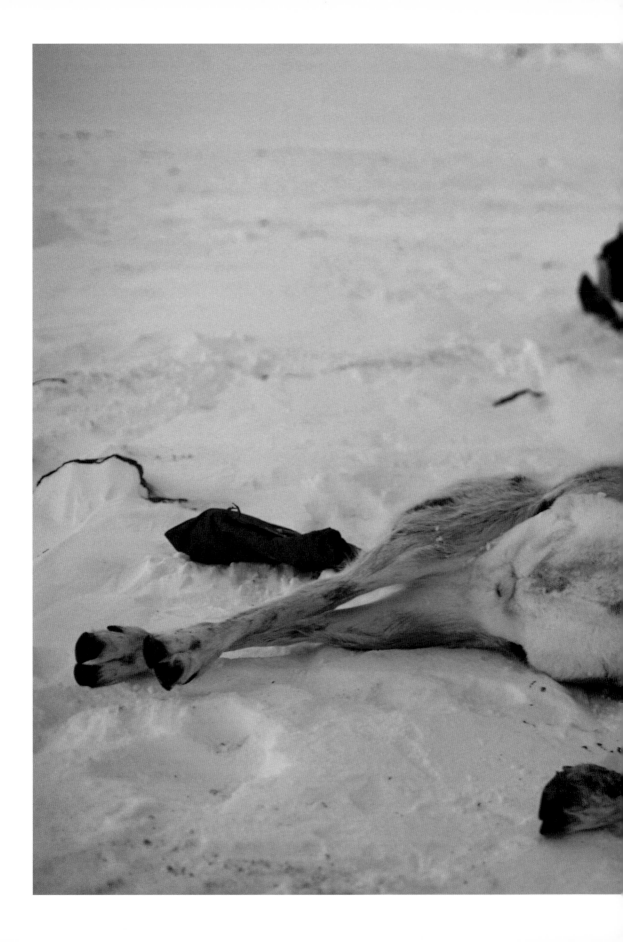

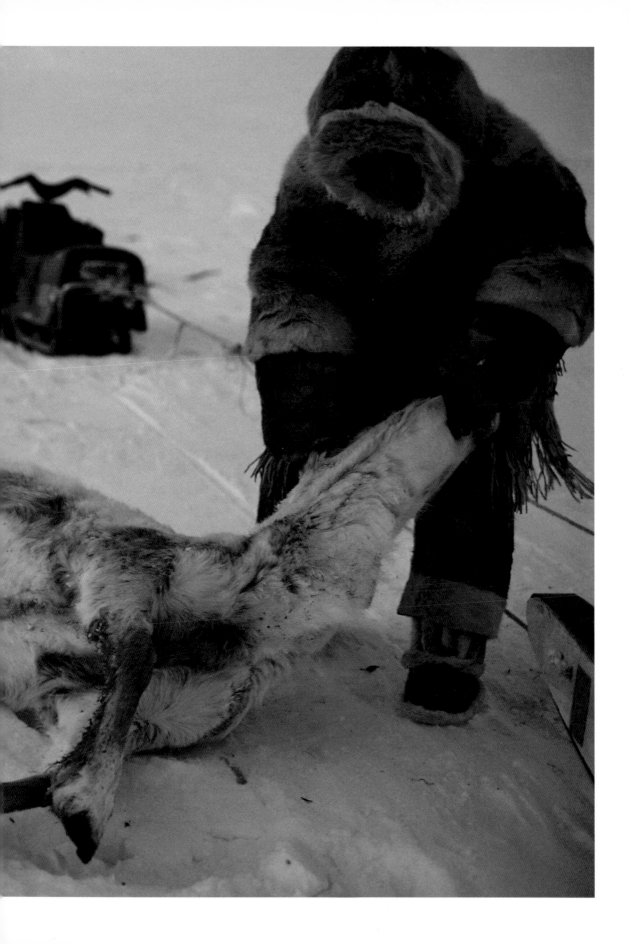

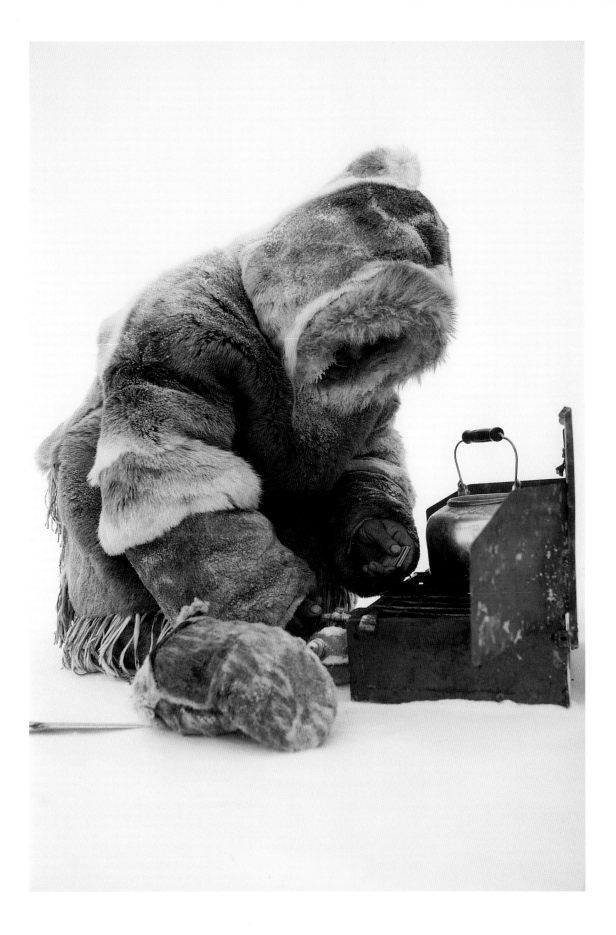

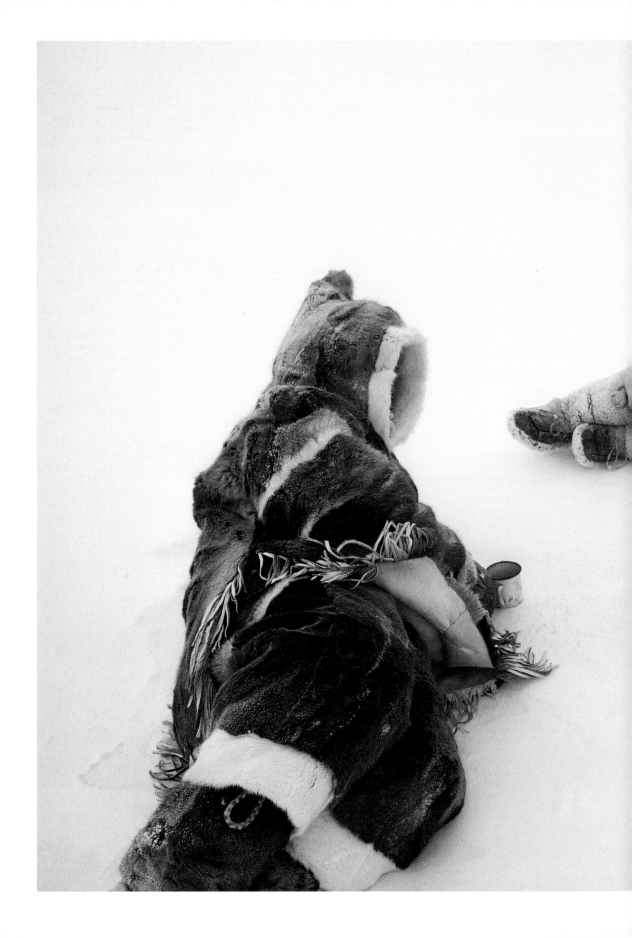

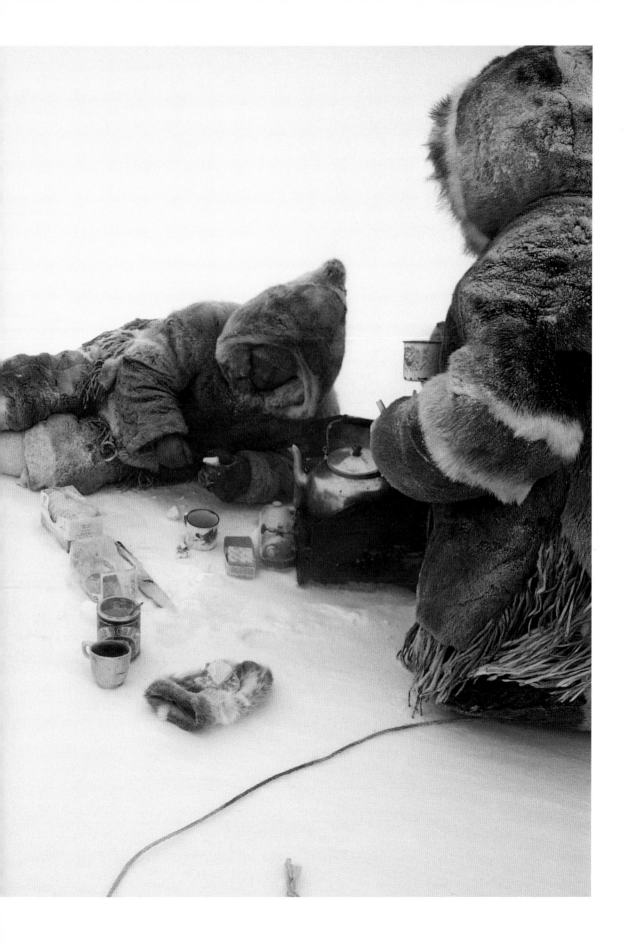

AFTERWORD ᑭ°ᒍᓂᐊᓂ ᐅᖅᑲᐅᔅᕆᒃᓴᑦ

Wade Davis

When the British first reached the Arctic they took the Inuit to be savages. The Inuit, for their part, took the British to be gods. Both were wrong, but one did more to honour the human race. What the British failed to comprehend was the fact that there could be no better measure of genius in the unforgiving Arctic landscape than the ability to survive with a material technology that was limited to what could be crafted and carved from bone, stone, sinew and ivory. The Inuit did not fear the cold; they took advantage of it. The runners of their sleds were first made of fish — Arctic char laid in a row and wrapped in hide which, once frozen, was greased with the stomach contents of a caribou.

The early European explorers who mimicked these ways achieved great feats of exploration. Those who failed to do so often suffered terrible deaths. The British, in particular, insisted on bringing their own environment with them rather than adapting to another. The last of Sir John Franklin's crew succumbed at Starvation Cove on the Adelaide Peninsula. The remains of the young sailors were later found frozen stiff in the leather harness of a sled they had been dragging behind them. The sled had been manufactured in England. It was made of oak and iron and weighed some 295 kilograms (650 pounds). On top of it was a skiff that weighed roughly 365 kilograms (800 pounds). Inside were all the accoutrements of a British naval officer's dinner service, including silver plate and a copy of the novel *The Vicar of Wakefield*. All of this the doomed men, already weakened by scurvy, had been attempting to haul through the vast expanses of the Canadian north.

The Inuit, by contrast, moved lightly on the land. At Cape Crauford at the northern tip of Baffin Island, I once visited a group of hunters from Arctic Bay who had set up camp at the mouth of Admiralty Inlet in order to hunt narwhal, beluga and other marine mammals. Each day they would move along the floe edge and peer out over the open waters of Lancaster Sound, watching and waiting. One evening one of the men, Olayuk Narqitarvik, told me a remarkable story, which at the time I found difficult to believe.

During the 1950s, the Canadian government, seeking both to curb a tuberculosis epidemic and to establish sovereignty in an archipelago that might well have been claimed by Europeans or Americans, forcibly moved

the Inuit into settlements. Olayuk's grandfather had categorically refused to obey. According to the story, the family, fearful for the old man's life, took away all of his tools and weapons, thinking that this would oblige him to acquiesce. He refused once more. Then, with a winter storm blowing, he slipped outside into the Arctic night, removed his caribou-hide trousers and defecated. As the feces froze, he shaped them into a knife, using a spray of saliva to hone a sharpened edge. As the implement took final form, hardened by the cold, he used it to kill a dog. He took the skin of the dog and improvised a harness, the ribcage to serve as a sled. He then rigged the works to another dog and, knife in belt, disappeared over the ice floe.

To this day, I do not know whether the account was true or whether Olayuk was simply feeding a naïve visitor a good yarn. I later read in the journals of the Danish explorer Peter Freuchen a casual reference that suggested the possibility that such implements were once made, at least in emergency survival conditions.

Apocryphal or not, the story always struck me as a marvellous symbol of the resilience, strength and ingenuity of the Inuit people. To watch an Inuk clean a carburetor with the delicate plumage of an ivory gull, or transform a round piece of junk metal into a clutch plate by bracing it with his feet and blasting a circle in the metal with a rifle shot, is to witness a spirit of the practical that resonates throughout the tradition and that is perhaps the key to the Inuit's cultural survival.

We are living through a time of unprecedented transformation. Of the 6,000 languages spoken throughout the world today, fully half are not being taught to children. Within a generation we are witnessing the loss of half of humanity's spiritual, intellectual and social legacy. This is the hidden backdrop of our age.

Not long before she died, the anthropologist Margaret Mead said that her greatest fear was that as we drift toward some blandly amorphous generic world of modernity, not only would the entire range of the human imagination be reduced to an increasingly narrow modality of thought, but that we would wake one day, as from a dream, having forgotten that there had ever been other possibilities for life.

As the remarkable photographs in this book attest, much has changed for the Inuit in the last decades. But it is important to remember that change in itself is no threat to culture. All peoples through all time have adapted to new possibilities for life. Nor does technological innovation necessarily compromise a people. The Inuit did not cease being Inuit when they adopted the rifle any more than a Canadian farmer stopped being Canadian when he replaced the horse and buggy with the automobile. It is neither change nor technology that threatens the integrity of the ethnosphere, the cultural web of life that envelops the planet. It is power, the crude face of domination.

The myriad cultures under siege around the world are not failed attempts at modernity, destined to fade away as if by some natural law. On the contrary, they are in every instance dynamic living peoples being driven out of existence by identifiable external forces. This is, in fact, an optimistic observation, because it suggests that if people are the cause of cultural destruction, we can also be the facilitators of cultural survival. The goal is not to sequester individual societies in the past, frozen in time or in physical space like zoological specimens. One cannot make an Arctic refuge of the mind; to attempt to do so would be obscene. The goal is to find a way of ensuring that all peoples have access to the brilliance of modernity, without that engagement having to imply the eradication of their ethnicity. The choice is between a monochromatic world of monotony and a truly pluralistic and polychromatic world of diversity in which all peoples are free and empowered to choose the elements of their new lives.

The Inuit face enormous challenges, but today they hold their destiny within their hands. Canada has not always been kind to them. The abuses imposed over the years are a stain difficult to cleanse. But in 1999, in an unprecedented gesture of restitution for a nation state, Canada yielded administrative and political control of an area half the size of Western Europe to an indigenous nation. The creation of Nunavut, the Inuit homeland, has become a beacon for peoples throughout the world. What will become of it lies within the dreams and thoughts of the men and women, their children and grandchildren, portrayed in this exquisite book.

FIELD NOTES

ᐊᐳᑕᑐᖅᓯᒪᑐᓄᓂ
ᓇᓇᕐᖃᑕᑕᖅᑯᑕᐱᑦᑕᓕᑦ

and eat here. From decay comes a delicate ring of moss campion that grows on the perimeter of this little fertile oasis of Arctic habitation.

Frosted window of the old sewing centre. The centre was last used to produce the costumes for the 2001 film *Atanarjuat*.
Igloolik, 1978

The Twin En
the mountain
Baffin Island
then the pilo
ged coastline
tundra plate:
can see. Nur
miles, one-f
encompassii
(a populatio
26 square n
of the inhal
half are unc
North Baffin

Hiking al
lured to th
fjord, I of
sunshine, swallowed up in the magnificence and isolation of the High Arctic.
Milne Inlet, Eclipse Sound, North Baffin Island, 1998

er a
ther I
arly two
rged in
en valve
nks.
uit have
ody
parts and extremities, earlier ethnologists' reports that Inuit can work with bare hands in temperatures of -30 degrees F (-35 degrees C) without suffering frostbite. Inuit also have an increased basal metabolism rate, which keeps blood temperature up in cold surroundings. Some researchers believe another circulatory mechanism exists in the extremities, where warm arterial blood is shunted into a paired vein to heat venous blood *en route* to the heart. This allows the hands and feet to become cold without leading to the chilling of the brain and other internal organs.
Turton Bay Beach, Igloolik, 1977

A "matchbox" house in Igloolik — small, with thin walls, little insulation and big stoves. Matchboxes are what passed for housing in the 1950s. They were steamily overheated in the winter, when outside it was cold and bone-dry. At the time when everyone lived in these government-built houses, tuberculosis raged through Canadian Inuit settlements.
Igloolik, 1977

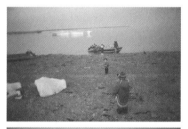

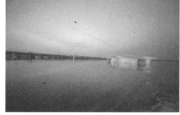

By the time we finish packing for our August weekend camping trip, it is

A rock, deposited here by glaciers, is now a thin ecological niche providing a home to lichen. Owls also perch, hunt

10:30 p.m., dusk in Igloolik. In the cold night, a wall of fog engulfs us. Andy Attagutalukutuk stops his 16-foot aluminum boat, looks around, motions a direction with his hand, and then proceeds slowly through the ice-strewn waters. We are on our way across Foxe Basin to an old hunting camp called Oopingiviajuk, on Baffin Island. Andy's wife Rebecca, who works as a teacher's aid at the school in Igloolik, rides beside him along with two of their children, Alice, 12, and Thomas, 4, who sleep soundly at their feet, swaddled in a sleeping bag laid on caribou skins in the bottom of the boat.

Turton Bay, Igloolik, 1998

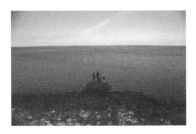

Fishing off a rock on the way to Oopingiviajuk. "We always caught many fish here," Rebecca says. Andy reminds me that it's Rebecca who always catches them. We stop and fish. Rebecca reels in three big Arctic char. The rest of us catch none.

Foxe Basin, North Baffin Island, Nunavut, 1998

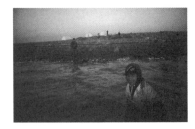

Kevin, Andy's eldest son, helps unload the boat in rough water, as the early spring morning light hits the gravel shores of his family's summer camping place.

Oopingiviajuk, North Baffin Island, 1998

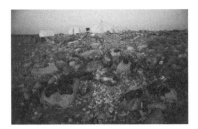

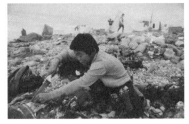

Caribou meat is strewn over rocks to dry outside the tents. In camp we all help ourselves to the meat whenever we want, and we sleep whenever we want. Here I lose all sense of time.

Oopingiviajuk, North Baffin Island, 1998

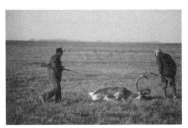

Paulosie Attagutalukutuk, Andy's father (left), and Methusalah Kunuk approach a bull caribou Paulosie shot near his family's summer camping place. Here Paulosie grew up and lived in a sod house until 1964, when his was among the last families to move permanently into Igloolik. The ice broke up in Foxe Basin only a few days before I took this photo.

Kangilujak, Steensby Inlet, North Baffin Island, 1976

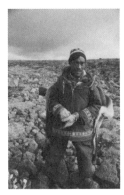

Paulosie carries a caribou skin and meat back to the boat near Kangilujak. When he was young, living meant hunting and blood meant life, and living the questions was more important than seeking the answers. He left the Arctic only once, in August 1997, when diagnosed with liver cancer. He died two months later. He was one of the last full-time Inuit hunters.

Kangilujak, Steensby Inlet, North Baffin Island, August 1976

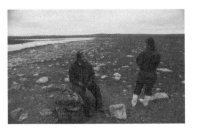

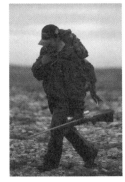

Esa Kripanik rests with fresh caribou meat that he is carrying back to camp. He and his wife, Teporah Qaunaq, who is Paulosie's niece, walked about five kilometres from camp to shoot this caribou.

Oopingiviajuk, North Baffin Island, 1997

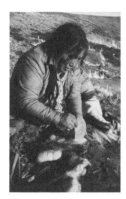

Rebecca Nagjugaq Irngaut scrapes and cleans excess fat and meat from a caribou hide with a curved knife called an *ulu*. She moves her hand repetitiously, almost meditatively, before pausing to bite, tear, pull and eat pieces of fat from the fresh skin. The skins are then pegged to the ground so they dry flat. Fall is when skins are best for making clothes, and also when the *tunnuq* (fat) is considered a delicacy.

Kangilujak, Steensby Inlet, North Baffin Island, 1978

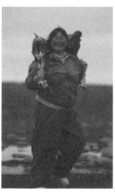

Papa stops to pose proudly with the young caribou carcass she carries to camp. Her real name is Rebecca Paapaaq Malliki. She is aunt to my old friend Rebecca Awa, who tells me, "Papa is unusual, because women don't normally go out hunting, let alone carry meat over their shoulders in the Amittuq region. But there are some exceptions; there are a few women who enjoy hunting and all that it entails, while many like myself thank God for

not having to do any of it, especially the killing and the butchering."

Oopingiviajuk, North Baffin Island, August 1998

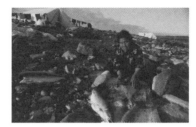

Deporah Qaunaq, Andy's aunt, fillets and prepares big red slabs of Arctic char, fresh from the nets in front of the camp. Often indistinguishable from the fish, her hands, like a sculptor's, move with speed, precision and dedication. Her husband Simeonie, a full-time hunter, defied the law and killed a bowhead whale so that his elderly father-in-law, Noah Piugattuk, could taste it once again before passing away.

Oopingiviajuk, North Baffin Island, August 1997

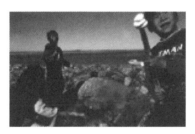

Boiling caribou meat and roasting marshmallows. Collecting enough small green sparse willow and bits of moss to make a fire, and keeping it going, are always challenging.

Oopingiviajuk, North Baffin Island, August 1997

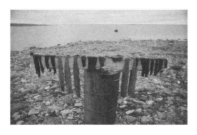

Caribou meat and Arctic char dry on a rare piece of salvaged wood, from an

old cabin, slung over one of the many abandoned fuel barrels that litter the Arctic.

Oopingiviajuk, North Baffin Island, August 1997

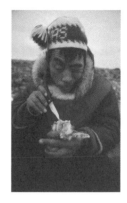

Andy picks marrow out of a bone, one of his favourite things to eat. He uses his knife, but sometimes he carves a little bone tool that slides into the leg bone so he can more easily scoop out the rich oily marrow. "I come here to eat," Andy says.

Oopingiviajuk, North Baffin Island, August 1998

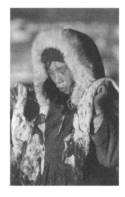

Andy carries caribou back-fat to camp. In the past, much of the meat would have been cached under piles of rocks, where it would age and remain protected from bears, wolves and foxes. The hunters would memorize the location and return to the cache in winter by snowmobile or dog team. The back fat, however, was always brought to camp immediately. Andy used to call it "Inuit bannock." It tastes

wild but good, and, when eaten with a piece of lean meat or chewed like waxy gum, the fat has a marvellous warming effect against the cold sea wind.

Kangilujak, Steensby Inlet, North Baffin Island, 1977

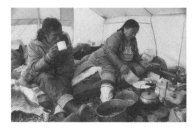

Isaac and Rebecca Irngaut make bannock with flour and seal fat. Isaac (Paulosie Attagutalukutuk's oldest brother) committed suicide by slitting his own throat. Rebecca Awa remembers him as a "very thoughtful man who cleared snow from the church and elderly people's steps all winter long."

Kangilujak, Steensby Inlet, North Baffin Island, 1978

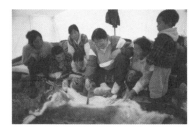

One Sunday morning, after a brief church service in Deporah's tent, both Papa (centre left) and Deporah (right) illustrate to young people in the camp how to cut a caribou skin to make a parka. "The neck is the strongest part," Deporah says. Women are always busy in camp. I remember Papa, whom I knew and photographed twenty years ago, making what she still calls "Eskimo popcorn." She cuts seal fat into pieces to fry, then renders the oil for burning in her lamp. When she's almost finished, she squeezes a few handfuls of well-chosen, very deep-fried, greasy but crispy morsels and passes them around

to the children. It makes her happy to show me how to mix equal parts moss and Arctic cotton grass to make the wick for her seal-oil lamp.

Oopingiviajuk, North Baffin Island, August 1998

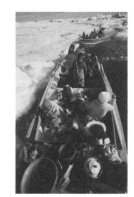

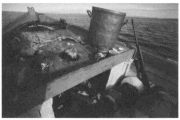

Paulosie stands on the food box in his old boat, aptly called the "chugger." His neck strains high, and his eyes dart back and forth across the white icy seascape that suddenly engulfs us. He mutters something in Inuktitut. Standing beside me at the gunwale of the heavy old Newfoundland fishing vessel, Andy shouts me a translation: "My father says he is afraid that we might get crushed by the ice." Paulosie was a profoundly calm man, and, seeing at this moment the uncharacteristic look of grave concern on his nearly always smiling face, I know that our situation is very precarious. We are 30 miles from the nearest point of land, in the northern reaches of Foxe Basin. There are nine of us: 45-year-old Paulosie; his wife Iga; their children Andy, Auksou, Jeanne, Johnny, Maliki and two-year-old Leita; and me. Earlier, we had moored Paulosie's boat alongside drifting pan ice to take on fresh water

and brew a pot of tea, a regular ritual in the course of our travels. At this stop, however, the current is different, and the ice constantly drifts and changes position. The wind and the strong whirlpool-like current are shifting, and the huge floating blocks of ice seem to swell and swirl around the boat like pieces of a gigantic jigsaw puzzle mightily trying to fit itself back together.

Cut off from open water, Paulosie begins to manoeuvre the 27-foot wooden boat through the massive floes, avoiding brushes with threatening blocks while searching for a lead of water that might allow us to slip out of the maze and back into the open sea. Iga, Andy and I run from side to side fending off the ice with tent poles and our feet. A house-sized, mushroom-shaped iceberg looms dead ahead, and Paulosie quickly shuts down the engine to prevent a collision.

This boat, which lesser people would consider completely unseaworthy, is powered by a venerable single-cylinder engine with but two speeds, Stop and Go. To change from forward to reverse, you have first to stop the engine, then restart it by rocking the flywheel. But now, as the ice closes in around us, it refuses to start. Frantically heaving on the massive flywheel, Paulosie attempts to coax a spark of life from the 40-year-old magneto. Andy moves to the stern with his pole; Iga stays at the centre with the children; I stand helplessly in the bow, waiting for the massive ice block to crash into us broadside, fearfully speculating on how long we might remain afloat after the impact. The old boat skids along the ice, knocking me off balance and down onto the deck while simultaneously shearing off the exhaust pipe and the mount of our small, presently inoperable auxiliary outboard motor. My thoughts turn, in panic, to abandoning the boat in favour of the ice floe, when the engine backfires and jolts to life. I feel the boat backing up, escaping the full force of the ice, which would

easily crush the hull like kindling.

Crisis past, I look back at Paulosie. His face breaks into a beaming, mischievous smile as he mimics how I almost fell between the ice and the hull. Everyone laughs as we move to safer waters, where we spend several hours repairing the damage before once again heading northeast across ice-strewn Foxe Basin. "That's happened to us before," Andy tells me later. "One time we had to stay on the ice for two weeks."

Foxe Basin, North Baffin Island, Nunavut, 1977

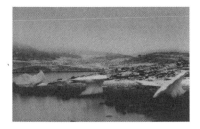

Paulosie's summer camp.
Kangilujak, Steensby Inlet, North Baffin Island, July, 1977

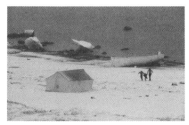

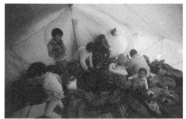

I lived with Paulosie and his family in this tent for over four months in the summer of 1976. My only privacy was when I closed my eyes.
Kangilujak, Steensby Inlet, North Baffin Island, 1976

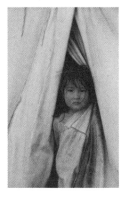

Jenny Irngaut peers out of the tent at her family's summer camping place. The family leaves Igloolik by boat every year to hunt caribou and to fish for Arctic char. She is now Jenny Awa.
Kangilujak, Steensby Inlet, North Baffin Island, 1976

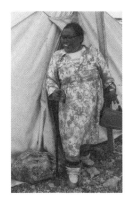

Martha Angugattiaq Ungaalaaq was Rebecca Awa's grandmother and the daughter of Wilfred Corone, who went with Joseph Bernier and the Hudson's Bay Company to trade for furs in Igloolik. Rebecca tells me that Martha was "adopted by a childless couple and was a strong woman who never complained about her once broken and chronically painful back."
Kangilujak, Steensby Inlet, North Baffin Island, 1976

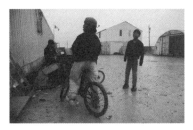

Igloolik's population has grown from 700 to 1,240 in two decades. Today fewer adults are hunters, and many children are called "town kids" because they have no interest in going on the land — or no one to take them there. Most of the employed work for some level of government. Boredom, television, gambling and community dances consume the weekends. Many, unfortunately, pass the time with alcohol. The suicide rate in Nunavut is between five and eight times the Canadian national average, and as high as fifteen times in some settlements.
Igloolik, 1998

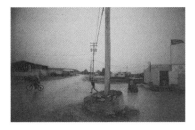

Igloolik has an elementary and a high school, Arctic College, and a video production company. A sewage pump-out system has replaced household "honey buckets." All the buildings are netted together by a maze of telephone and electrical wires, which run between poles firmly anchored in big pots of stone, built to withstand 100-mile-per-hour winter winds and located above ground because nothing can be buried here, where the ground is permafrost.
Igloolik, 1998

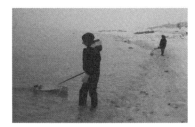

Turton Bay, Igloolik, September 1979

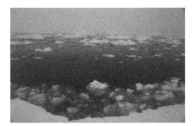

Solar power cracks the frozen hide of Lancaster Sound, and ice degenerates and recedes. At the whim of currents and winds, leads and waterways open and close, and the edge of the floe, where open water meets receding land-fast ice, is a prolific, nutrient-rich trove. The surge of life begins when the first light of February penetrates this frozen crust, vitalizing the algae blooms (containing diatoms) on the underside of the ice. Shrimp-like crustaceans called amphipods feed upon the algae, and then in turn lure an estimated half-million tons of Arctic cod to these waters. The food chain links a sun-powered profusion of phytoplankton and zooplankton to other small crustaceans, like copepods, and ends at the top with polar bears and people. A quarter of the world's beluga whales and three-quarters of the world's narwhals pass by these waters in spring, along with bowheads, killer whales and walruses. Hundreds of thousands of harp, bearded and ringed seals feed on the fish, as do millions of birds, including dovekies, guillemots, kittiwakes, murres and northern fulmars.

Floe edge, Lancaster Sound, North Baffin Island, 2000

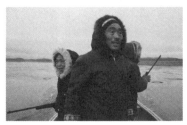

Paulosie and sons Andy and Molokai hunting seals. This was mostly a matter of waiting quietly for long periods until a seal would stick its head out of the water, or until people got tired of waiting, which was hardly ever. Paulosie had enduring patience. Time didn't have much meaning for him. He just did what had to be done, no matter how long it took. We once spent a week camped on the beach of a small unnamed island fixing and replacing with walrus skin the rubber bushings around the propeller shaft of his old boat.

Steensby Inlet, North Baffin Island, 1977

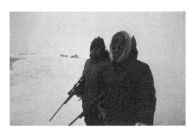

Aime Panimera waits for seals at the floe edge with his brother-in-law, Josiah Inooya, in 1977. Twenty years later Aime became the mayor of Igloolik and one of the big cheerleaders of Nunavut. "Enough is enough of the federal government and the government of the Northwest Territories trying to run our lives, which they don't understand," he says over tea at Rebecca Awa's house. He feels that the present is still tied to the old way of life: "We are not business people, at least I am not, and when I think of all the people who live in Igloolik, there is only one Inuk who is successful in business here, after all these years …"

"This is difficult for me to tell you," he says, with his boyish, gentle shyness. "I hardly ever went out on the land. I could usually count on receiving meat from my uncle who hunts. Not long ago he got a narwhal, so I went to his house expecting to be given some *maktaq* [whale skin, and a great Inuit delicacy]. But when I got there, he had sold it to the Hunters and Trappers Association and said that if I wanted *maktaq*, I would have to go there and buy it."

Floe edge, Fury and Hecla Strait, Igloolik, April 1977

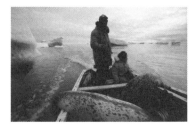

Seal hunter Augustin Taqqaugaq and his son Lukie motor through the shifting autumn ice floes of Foxe Basin. At this time of year, seals sink quickly after they are shot, and many are lost before they can be hauled into the boat.

Foxe Basin, Igloolik, September 1979

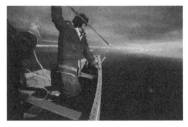

Harpooning a seal after it has been shot, and before it can sink. How quickly a seal sinks depends on the season, how fat the seal is, and the currents, temperature and salinity of the water.

Foxe Basin, Igloolik, 1976

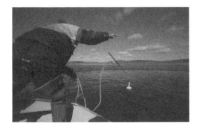

Kevin, Andy's eldest son, harpoons a moulting goose. Having spotted the geese on the land, Andy immediately put his six-year-old son Tom ashore with instructions to chase them into the water. When I asked why they were harpooning the goose instead of shooting it, Andy joked that he "didn't want to waste a bullet." In truth, his large-calibre gun would damage the delicate meat excessively.

Foxe Basin, North Baffin Island, August 1998

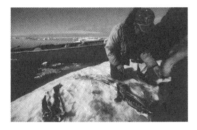

We stop on pan ice to eat seal meat and collect fresh water for tea. The first time I ate raw seal liver I was very pleasantly surprised that it tasted so sweet and mild. It seems like the perfect food to eat out here.

Foxe Basin, Igloolik, 1976

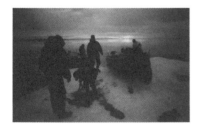

Hunters stop for a lunch of raw seal meat.

Foxe Basin, Igloolik, 1998

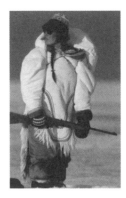

Rebecca Paapaaq Malliki, "Papa," stands motionless over a seal's breathing hole. She carries a small baby on her back, inside her parka or *amunti*. When you're hunting seals on the rough sea ice, the challenge is first to recognize and locate all the breathing holes within an area, and then to disturb most of them so that the seals are discouraged from using them. The seals will be forced to use the undisturbed holes. Here, one must stand very still, with a harpoon or gun, hoping that a seal comes up for air.

Foxe Basin, Igloolik, April 1976

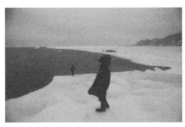

"If you watch closely you will see the ice move beneath us," says Leo, a 42-year-old Inuk from the community of Arctic Bay. For two weeks, he has a job guiding ecotourists, who bounce along a sled behind his snowmobile over the transforming floe edge of Lancaster Sound, looking for wildlife. Three female narwhals, only their backs briefly visible, have just passed within 200 metres of where I stand. The only sounds come from water splashing on ice and, awe-inspiringly, from whales breathing. When the whales submerge, I try to track their wakes and imagine where they will

resurface, but they are gone as quickly as they arrived. And when I turn away from the dark water, the bleak ice vanishes into infinity. There is little difference between sky and frozen sea, and the lack of discernible relief in the seascape distorts my sense of distance. Determined to see the ice move, I gaze intently at a selected spot. At a mysterious distance away, I watch for several minutes before my eyes — or is it my senses? — detect what Leo, from experience, can perceive easily. I see before I feel an exceedingly faint wave-like motion that lifts and lowers me, the massive slab of five-foot-thick ice on which I stand floating on hundreds of feet of water. The feeling severs me from all human proportion.

Cape Crauford, Lancaster Sound, North Baffin Island, August 2000

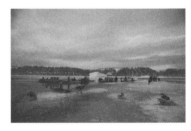

Eco-tourists

Cape Crauford, Lancaster Sound, North Baffin Island, August 2000

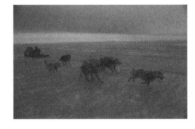

Looking for seals

Cape Crauford, Lancaster Sound, North Baffin Island, August 2000

152

Woman in the old sewing centre softens skin by chewing it.
Igloolik, 1978

For over 5,000 years, Inuit have had to learn how to live in the moment and be extremely practical. This was the essence of their survival. Often today, especially in settlements, things like tools and machinery are abandoned when they have outlived their immediate usefulness. Like the time Andy Awa's snowmobile fell into the water during the spring thaw. His response: "I don't need it now anyway."
Igloolik, 1978

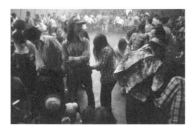

Isaac Ungalaq laughs it up at a weekend community dance contest, while his wife Mary pins fabric to the back of his pants.
Igloolik, 1978

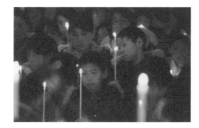

Christmas Mass at the old stone Catholic church.
Igloolik, 1976

Building an igloo. "The snow is very poor here, too soft on top and too hard at the bottom … but it is the best we have found," Andy Attagutalukutuk says. We have to cut blocks "on the horizontal, flat side up," out of the middle of this snow patch. He spirals the blocks around himself like a snail building its own shell, which rises higher and higher; it's like winding a little womb in the wilderness. As he adds blocks, they shield him more and more from the wind, which is now very strong and so paralyzingly cold that even short exposures are lethal to living tissue. "Left-handed people build igloos in a clockwise direction, and right-handed people go counterclockwise, but there are not many people who build them properly any more," he says.

I wake up cold and shivering. The stove is out of fuel, and the gas lantern flickers red and blue with its last light. Frost covers everything: the walls of the igloo, the stove, and my clothes, which were wet with perspiration last night but are now frozen solid. Large crystals of ice have grown in the cracks between the snow blocks, where moisture meets the cold air. I feel very far away from the rest of the world, as if I were inside a troglodyte cavern 10,000 years old. Andy wakes up, we fill the stove, and I feel warmth again. Andy throws an extra mantle for the lantern on the stove's burner, for extra light. We eat the last of our bacon, frozen solid and raw, along with two more cans of sardines, which we heat up and spread over the last of our pilot biscuits.

Last night Andy made a beautiful and ingenious candle lantern by hollowing out a block of snow in a cone shape. Something his uncle showed him.
North Baffin Island, Igloolik, 1999

A woman inside an igloo with a *qulliq*, or seal-fat lamp, which needs to be attended constantly. I remember sleeping in an igloo when the *qulliq* got out of control and blackened the inside walls. The next morning my nose was full of greasy carbon from burnt seal fat.
North Baffin Island, Igloolik, 1976

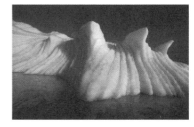

I photographed this iceberg from my kayak, naming it Ulli after a dear friend.
North Eclipse Sound, North Baffin Island, August 1997

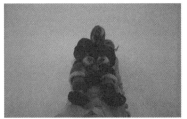

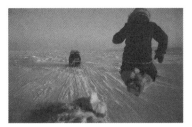

This man shot a seal from the ice edge and is retrieving it using a very small homemade plywood boat. At this polynya — an area of sea that remains free of ice — the currents of the Fury and Hecla Strait create a mix of high nutrient levels that make the floe edge an excellent habitat for seals, walruses and whales, and the supply of food in the year-round open water is the reason that people have been inhabiting Igloolik Island for over 5,000 years.
Floe edge, Foxe Basin, Igloolik, April 1975

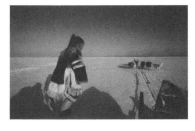

Seal hunters head their dogs towards the mist of the floe edge, where open water meets land-fast ice and the mixing currents keep the water open all winter long.
Floe edge, Foxe Basin, Igloolik, 1976

I spent many hours riding *qamuti* (sleds). Hanging on and contending with the biting wind chill are relentlessly challenging. With every turn, I adjust my caribou parka hood, and with it the wind's angle of attack against my face. When I feel solid spots — frozen flesh — I hold my mitts against my cheeks, but then there is a gap between my mitts and parka, where searing wind bites a thin frozen ring around my wrist.

The *qamuti* creaks, rumbles and whispers differently with each moment of terrain. The two heavy timber runners and 12 wooden crosspieces are all lashed together on the *qamuti* with the skin of bearded seal, so the sled remains flexible and pliant in all directions. It changes shape and adjusts to every bump and contour. Over ice, it resonates like a hollow drum. Passing over deep snow drifts, the *qamuti* whispers softly. Gravel produces a horrible rumble. When we go over pressure ridges, especially when bigger pieces of ice hit the runners, it becomes critical to keep both legs away from the edge. At times it is like riding a bucking bull on a fast-moving conveyor belt.
Floe edge, Fury and Hecla Strait, Foxe Basin, 1976

Andy Awa was always happy to go caribou hunting, and he was a real joker. Andy's late grandfather Awa was a great shaman, and Rebecca, Andy's widow, remembers him telling her that he had to be treated like his grandfather. "He was very spoiled when he was a child," she tells me, "like Sheba our daughter is by my father. She is named after my grandfather, who disappeared while he was hunting. When my father was young, he used to watch the hunters coming back to camp, hoping his own father would be among them. He treated my daughter Sheba just like she's his father who has returned. He sometimes called her 'father,' and he really spoiled her."

Andy has had three Inuit names: Uruluk, after his paternal grandmother; Ukkuq, after his older half-brother; and Uvvattuattiaq, after a paternal cousin. The federal government issued Eskimo Identification Canada tags, and Andy gave me his. I still have it. His name was number E.5-192.
North Baffin Island, Igloolik, 1979

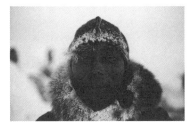

Herve Paniaqm, an avid and dedicated hunter.
Igloolik, February 1977

After a long night of fixing, re-fixing, and fixing again a breakdown on Andy Attagutalukutuk's snowmobile, we arrived at this tiny hunting cabin, all snowed in. "We will sleep here tonight," Andy says, as if there were any doubt. All this time I had assumed we would eventually build an igloo to sleep in, as we did 20 years ago when I travelled with Inuit hunters, like Andy's father Paulosie. I am cold, tired, and delighted to accept the end of intrigue for now. And when I look at our little cozy cabin here in this black, cold wind, it becomes staggeringly obvious why building an igloo makes no sense. Harry is here too, busy unpacking his *qamuti*.

"I stayed here last winter. That window was broken by a polar bear," Andy says, referring to a damaged and repaired window frame. What a remarkable place this is. Twenty years ago, there were no cabins like this. Around 9:00 p.m. we hear snowmobiles outside. The door soon swings open, cold rushes in, and out of the cloud come two fur-clad Inuit hunters. This time it is two brothers, whose father owns the taxi business in Igloolik. I watch them pull off their fur parkas, seal-skin pants, and layers of clothes: caribou socks, then wool duffle socks, then plastic bags inside those, and then a seal-skin boot inside the plastic. Andy and I make room for them on the sleeping platform. I introduce myself, but there is no response. "They are quite deaf," Andy explains. "If you find an old man who isn't deaf [from gunfire and snowmobile noise], it means he hasn't been hunting much." Andy himself is very deaf.

North Baffin Island, Igloolik, 1999

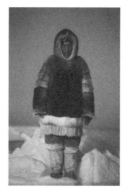

Semi Malliki hunting seals. The son of Noah and Elizabeth Piugattuk, he has moved to Repulse Bay. When I showed this photograph to an old Inuk friend, she told me, in her shy, non-judgemental way: "Don't print this, but his parka would be considered very ordinary, because it looks like whoever made it ran out of the white fur to put around the arms."

Floe edge, Igloolik, 1977

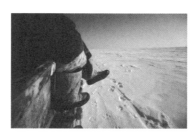

A hunter wearing waterproof sealskin *kamak*s drives his dog team, pulling a small plywood boat he uses to retrieve seals after shooting them.

Floe edge, Igloolik, 1978

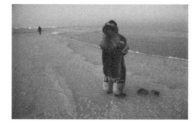

Andy Awa waits for seals.

Floe edge, Igloolik, 1978

Two Igloolik hunters have tea and wait by their *qamuti* for seals.

Floe edge, Igloolik, 1977

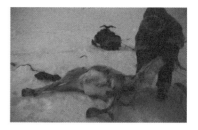

I took this photograph on my first trip out onto the land in the winter of 1976, hunting caribou with Alain Iyerak. We skinned this caribou and ate the warble fly larvae that live under the skin. It was early April, and we were going across the Foxe Basin ice to Baffin Island in white-out conditions, in fierce winds and a temperature of -40 degrees F (-40 degrees C). The relentless cold was overwhelming, often mesmerizing, turning ordinary tasks into monumental feats. We'd leave our caribou clothing outside the igloo at night, and then in the morning we would beat the frost and moisture out and begin again with dry but very cold clothing.

The white-out obscures the horizon, rendering the landscape seamless. The only way I can tell if we are going up or down is by watching to see if the rope that connects the *qamuti* to Alain's speeding snowmobile is slack (downhill) or taut (up). Suddenly the front of the sled rocks violently to one side, and the next thing I know, I am rolling to a stop, relieved to hear no bones break but instantly aware of the sound of Alain's snowmobile fading into deep whiteness. I stand up in my caribou

furs, afraid to move for fear of losing track of which way he went. In minutes the biting wind scours the *qamuti* tracks. I stand with no perception of depth or distance. I start walking towards a piece of ice jutting up, thinking I'll try to get up high to see farther. A piece of ice only a few metres from where I stand initially looks far, far away. There is only white, with shades of vertigo and confusion. I want to look at my watch, but I don't want to open the space between my mitt and parka sleeve for fear of letting precious heat escape. I do it anyway. It's 2:30 p.m., and dusk is arriving. The wind bites at the exposed crack around my wrist. It burns until I let the fur converge again and seal up the space. I walk on the spot and sing nonsensical Russian folk songs loudly. I wait and wait, singing and soon dancing softly in little circles, getting steadily more paranoid, wondering if Alain even realizes yet that I'm missing. Then, after nearly 45 very long minutes, I hear the far-away drone of a snowmobile, and out of the whiteness comes Alain. A half-smoked cigarette hangs out of his mouth as he races past me to swing his machine and *qamuti* around. He barely stops, and I hardly have time to jump on, before he speeds off into the fading flat whiteness, as if nothing had happened.

Alain navigates by watching wind-blown snowdrifts. When we finally arrive on the coast of Baffin Island, he discovers that his gun has shaken off somewhere on the sea ice. Fortunately he has another, and after shooting several caribou, we build an igloo and settle down inside our warm little glowing dome. Days later, on our return to Igloolik, there is still no visible horizon. Suddenly Alain stops, unhooks the *qamuti* and, without a word or sign, disappears into the reliefless landscape. He returns 30 minutes later with all the pieces of his lost and broken rifle accounted for.

North Baffin Island, Igloolik, April 1976

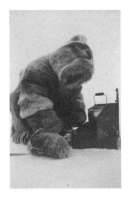

Stopping for tea, Alain shields his camp stove from the wind in order to light it. A good way to start a cold primus stove is to pinch a little caribou fur from your parka and lay it around the element. The fur ignites well. Harsh Arctic realities are nowhere more manifest than in winter, on either land or sea ice. The distinction between "land life" and "settlement life" becomes obvious when you return to Igloolik after sleeping in igloos or hunting cabins, with only a *qulliq* for light and warmth. Approached from a distance, Igloolik appears like a flickering jewel on the horizon, a grand spectacle. An intensely inviting womb of warm light that I am desperate to reach.

North Baffin Island, Igloolik, April 1976

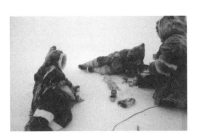

Caribou hunters having tea on the ice.
North Baffin Island, Igloolik, 1976

My winter *kamak*s. Susan Avingaq, Rebecca Awa's mother, made my first pair. I still have them. I keep them at home in the freezer.
Floe edge, Foxe Basin, Igloolik, 1998

Raincoast Books gratefully acknowledges the financial support of the Province of British Columbia through the BC Arts Council and the Book Publishing Tax Credit and the Government of Canada through the Canada Council for the Arts, and the Book Publishing Industry Development Program (BPIDP).

Edited by Naomi Wittes Reichstein and Scott Steedman
Cover and interior design by Judith Steedman, Steedman Design

Library and Archives Canada Cataloguing in Publication

Semeniuk, Robert
 Among the Inuit / Robert Semeniuk.

ISBN 10 1-55192-869-8
ISBN 13 978-1-55192-869-2

 1. Inuit—Pictorial works. 2. Inuit—Hunting—Pictorial works.
I. Title.

E99.E7S425 2007 971.004'971200222 C2006-904033-8

Library of Congress Control Number: 2006930535

Raincoast Books In the United States:
9050 Shaughnessy Street Publishers Group West
Vancouver, British Columbia 1700 Fourth Street
Canada V6P 6E5 Berkeley, California
www.raincoast.com 94710

Printed in China by Paramount Book Art

10 9 8 7 6 5 4 3 2 1